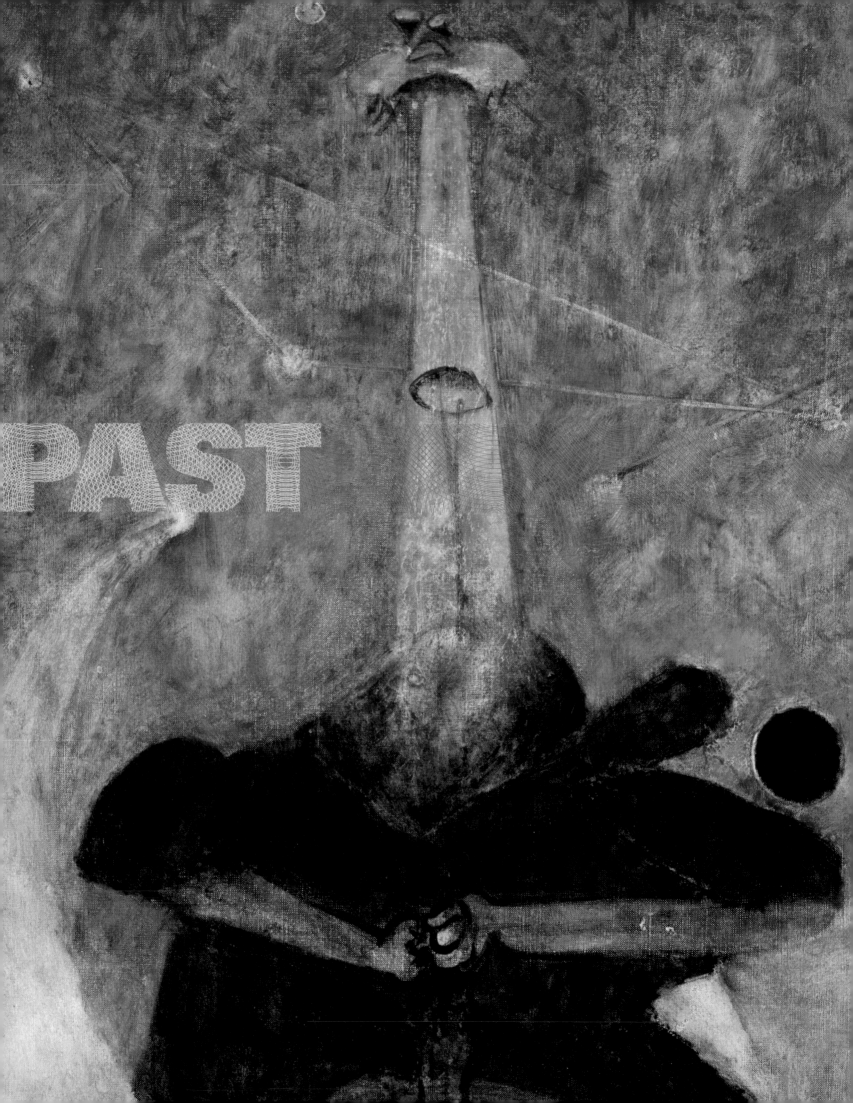

Bowdoin College Museum of Art
Brunswick, Maine

The MIT Press
Cambridge, Massachusetts
London, England

PAST

SCIENCE FICTION, SPACE TRAVEL, AND POSTWAR ART OF THE AMERICAS

SARAH J. MONTROSS

with contributions by

RODRIGO ALONSO

MIGUEL ÁNGEL FERNÁNDEZ DELGADO

RORY O'DEA

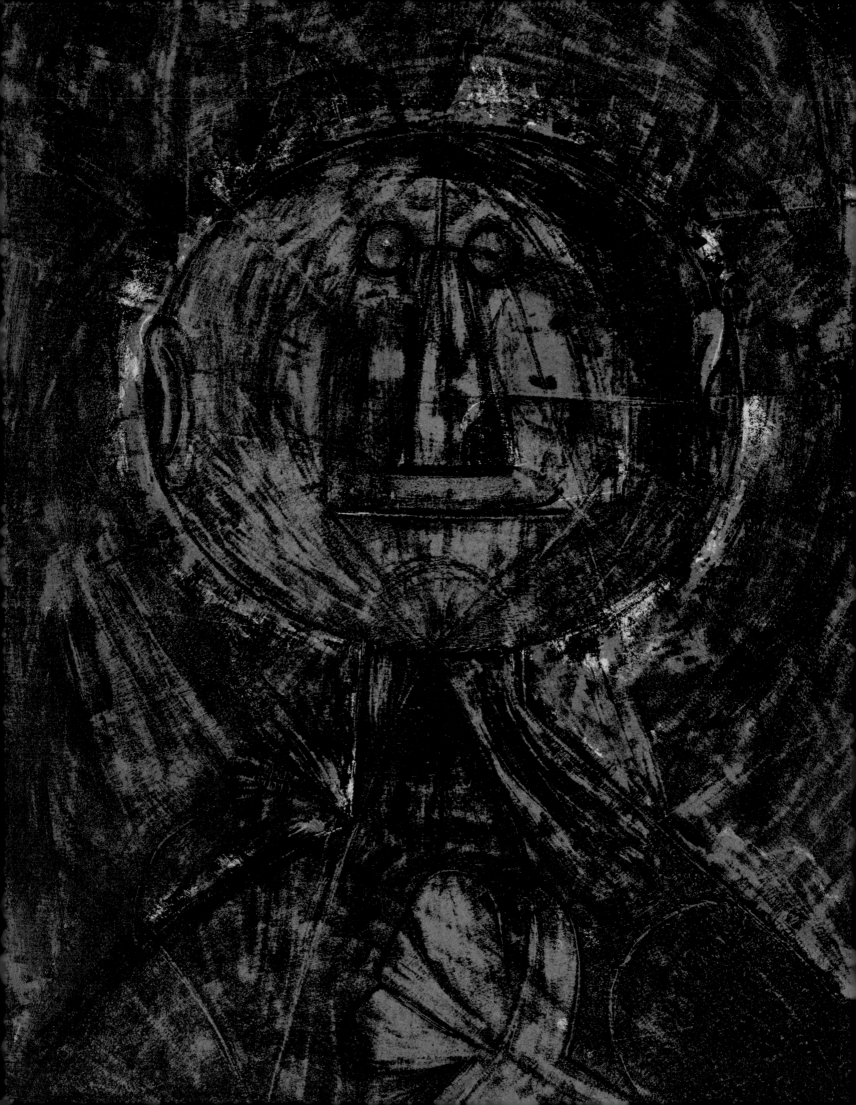

CONTENTS

EXPLORING

border crossings of all sorts—temporal, cosmic, and geographic—*Past Futures: Science Fiction, Space Travel, and Postwar Art of the Americas* brings into focus the fascinating themes of science fiction and space travel, subjects that shifted from fantasy to reality with the launch of Sputnik in 1957. The flight of Soviet cosmonaut Yuri Gagarin marked the advent of human space travel in 1961, and with the lunar touchdown of the United States' Apollo 11 in 1969, the boundaries that had once seemed fixed tumbled away and a broad, previously unimaginable range of possible futures arranged themselves on the edge of a new frontier.

The triumphal narratives that emerged from the successful realization of space travel had important political implications, and today the political and economic impact of satellites designed for communication and surveillance remains a defining, if easily overlooked, aspect of contemporary life. Space exploration was conceived, at least in part, as a show of force and technical and scientific dominance on the part of superpowers eager to persuade less-powerful nations of the value of their respective political systems. Yet the influence of these missions on art has been surprisingly under-examined.

Intriguingly, just as extraterrestrial travel invited speculation about the exploration of other planets, so too has this new chapter of discovery suggested powerful metaphors for exploring contemporary political, social, and economic realities on earth. In the context of the success of lunar travel and the construction of orbiting laboratories, science fiction and artistic renditions of as-yet unknown worlds gained a new authority and significance as the potential site of road maps and cautionary tales for the future.

The "new world" opened up by space exploration inevitably recalled historic tropes of conquest and exploration. The United States and other nations of the Americas, occupants of the New World that had been mythologized by Europeans centuries earlier, seemed once again to share a common destiny. It was certainly politically expedient for the United States to emphasize this shared history and geography with Latin America in light of larger Cold War political objectives. Yet this claim for unity, along with opportunities for new expeditions into uncharted territory and the technophilia of the period, did indeed galvanize a diverse range of artistic discourse and production throughout North, Central, and South America, as reflected in this groundbreaking exhibition.

In this context, exhibition curator Sarah J. Montross explores the impact of space travel and science fiction across the Americas, looking at the work of some twenty artists based throughout the two continents and comparing their otherworldly visions. The contrasts—and parallels—between past and future in many nations boasting ancient ruins of earlier civilizations set up suggestive and sometimes unsettling questions about the value, cost, and very nature of "progress." As the space age fed and challenged visions of international cooperation, especially those of opposing political regimes from across the globe, fascinating questions about the relationships of neighboring nations of the American continents also emerged.

These constellations of concerns manifest themselves in *Past Futures* through multiple artistic media and idioms. Each of the distinguished catalogue essayists addresses different aspects of this artwork. Montross writes an overview of *Past Future*'s themes of space travel and science

fiction in avant-garde art of the Americas in the context of pan-Americanist cultural diplomacy. Miguel Ángel Fernández Delgado provides a meditation on Latin American artists whose work relates to astronomic phenomena, utopian projects, and their fear and fascination with the modern machine. While Montross and Fernández Delgado broadly map many relevant artists and topics across the American continents, Rodrigo Alonso and Rory O'Dea offer more concentrated studies. Alonso explores how scientific fact and fiction permeated the Argentine art scene during the 1960s, a decade of ebullient optimism as well as increasing oppression. Finally, O'Dea considers how the science-fiction genre provided Robert Smithson with the tools to probe language, representation, and rational systems of knowledge, a practice that culminated in his seminal photo-essay "Incidents of Mirror-Travel in the Yucatan." We express our utmost appreciation to these scholars.

We also thank our colleagues at lending institutions and galleries, as well as the individuals who have made this project possible, including Art Museum of the Americas; Blanton Museum of Art, the University of Texas at Austin; Harvard Art Museums; Henrique Faria Fine Art; Leslie Tonkonow Artworks + Projects; the Metropolitan Museum of Art; Smith College Museum of Art; Solomon R. Guggenheim Museum; Williams College Museum of Art; and Yale University Art Gallery; as well as Marilys Belt de Downey, Thomas R. Monahan, and Gilbert and Lila Silverman.

Special thanks to Ed Marquand and Adrian Lucia at Marquand Books and Roger Conover at MIT Press for their assistance in crafting this publication.

We are especially grateful for the ongoing support of the Andrew W. Mellon Foundation, whose generous endowment provides critical resources for the engagement of the museum with students and faculty at Bowdoin and helped to underwrite this important exhibition.

We thank our colleagues throughout the Bowdoin community for their support and assistance, including, in particular, Barry Mills, president of the college, Cristle Collins Judd, dean for academic affairs, and Ann Ostwald, director of academic budget and operations. And we especially wish to acknowledge Sarah Montross for her vision and persistence in the conception and curation of this exhibition, and for her skillful coordination of this accompanying publication. As always, we offer our sincere thanks to each and every member of the staff at the Bowdoin College Museum of Art.

As *Past Futures* suggests, the shattering of the limitation of earth's gravitational field by cosmonauts and astronauts signaled not only a technological victory but also a victory of the imagination. The artwork presented here, in turn, pushed new boundaries: political, aesthetic, and conceptual. There are unexplored terrains that promise to challenge and realign past criteria of visuality, temporality, and possibility as we envision and enact our own tomorrow.

ANNE COLLINS GOODYEAR
Co-director, Bowdoin College Museum of Art

ACKNOWLEDGMENTS

THE experience of organizing *Past Futures: Science Fiction, Space Travel, and Postwar Art of the Americas* for the Bowdoin College Museum of Art has exceeded my expectations in countless ways. In the process of researching and planning this exhibition and catalogue, I learned that the intersections among science fiction, space travel, and art of the Americas are far more expansive than I first imagined. I have also been trusted with resources and support that far surpassed my initial hopes. First and foremost, I am enormously grateful to the Andrew W. Mellon Foundation for providing funding for travel, research, exhibition planning, and the publication of this catalogue.

It has been an honor to work with the catalogue's three extraordinary essayists, who have contributed substantial new scholarship on the themes of science fiction and space travel in avant-garde art. To Rodrigo Alonso, Miguel Ángel Fernández Delgado, and Rory O'Dea: thank you for sharing essays, images, and many conversations. I am also tremendously grateful to have worked with a copublisher as distinguished as MIT Press. My special thanks go to Roger Conover, executive editor; Justin Kehoe, assistant acquisitions editor; and Kate Elwell, production coordinator. I am deeply indebted to the design and production team at Marquand Books: Adrian Lucia, partner and managing director; Jeff Wincapaw, design director; Melissa Duffes, managing editor; Zachary Hooker, designer; Rebecca Schomer, accounting manager; Ryan Polich, design and production assistant; and Kestrel Rundle, editorial assistant. Janice Jaffee provided professional and timely translations of the Spanish-language essays. I also express my utmost gratitude to Nola Butler, an astute and patient editor, who helped me to navigate many aspects of the publication process.

Numerous institutions, foundations, galleries, and colleagues have assisted with innumerable requests related to this exhibition and catalogue: Andrés Navia and Adriana Ospina, Art Museum of the Americas; Simone Wicha, Beverly Adams, Amethyst Beaver, Meredith Sutton, and Stephanie Ruse, Blanton Museum of Art, the University of Texas at Austin; Thomas W. Lentz, Carrie Van Horn, and Isabella Donadio, Harvard Art Museums; Henrique Faria and Eugenia Sucre, Henrique Faria Fine Art; Leslie Tonkonow, Tyler Auwarter, and Janet Tham, Leslie Tonkonow Artworks + Projects; Thomas P. Campbell, Jeff L. Rosenheim, Anna Wall, and Nesta Alexander, the Metropolitan Museum of Art; Jessica Nicoll, Linda Muehlig, and Louise Laplante, Smith College Museum of Art; Richard Armstrong, Susan Davidson, and Carmen Hermo, Solomon R. Guggenheim Museum; Christina Olsen, Diane Hart, Rachel Tassone, and Kathryn Price, Williams College Museum of Art; Jock Reynolds and Suzanne Boorsch, Yale University Art Gallery; as well as individual lenders Marilys Belt de Downey, Thomas R. Monahan, and Gilbert and Lila Silverman. Additional thanks are due to Inés Berni, José Berni, Gustavo Bonevardi, Laura Cohen, Sergio Domínguez Neira, Adriana Donini, Kerry Gaertner, Elizabeth Goizueta, Emily Greer, Robert Hensleigh, Alejandro Jodorowsky, Kara Lenkeit, Jackie Maman, Heather Monahan, Mónica Montes, Max Pérez Fallik, Taiyana Pimentel, and Lorna Tucci.

Artists Mario Gallardo (Odrallag), Peter Hutchinson, Gyula Kosice, and Ivan Puig welcomed me into their homes and studios and shared many insights about their works. Additional artists and scholars generously shared their knowledge on themes related to science fiction and space travel in twentieth- and twenty-first-century art, including Andrés Burbano, Juan José Diaz Infante, Daniel Garza-Usabiaga, Pablo Hare, Rachel Haywood Ferreira, Linda Dalrymple Henderson, Christina Hunter, Gabriel Pérez-Barreiro, Martica Sawin, Itala Schmelz, Edward J. Sullivan, Regina Tattersfield, and Michael Wellen. I am also thankful for the advice and assistance of academic and curatorial colleagues, including Denise Birkhofer, Katherine Brodbeck, Luis Castañeda, Vanessa Davidson, Jennifer Josten, Carla Macchiavello, Abigail McEwen, Beth Matusoff Merfish, Jodi Roberts, and Ileana Selejan.

This exhibition and catalogue received remarkable support from the talented and dedicated staff at the Bowdoin College Museum of Art. I am tremendously grateful to Anne Collins Goodyear and Frank H. Goodyear, co-directors, for their unflagging encouragement and wisdom. I also thank Rebekah Beaulieu, assistant director of operations; Suzanne K. Bergeron, assistant director for communications; Elizabeth A. Carpenter, interim registrar and collections manager; Martina Duncan, former associate director of operations; Michelle Henning, assistant to the registrar; Joseph Hluska, preparator; Joachim Homann, curator; Laura Latman, former registrar and collections manager; Liza Nelson, museum shop manager; Christine Piontek, assistant to the directors; José L. Ribas, preparator; Andrea Rosen, curatorial assistant; Tim Hanson, manager of museum security operations, and the security officers whom he oversees; and John Eric Anderson, museum volunteer. I also wish to thank Cordelia Miller, class of '15, and Jessica Holley, class of '15, summer education assistants, Quinn Rhi, class of '15, student assistant to the curator, and especially Kiyomi Mino, class of '16, student assistant to the curator, who went above and beyond in assisting me in many aspects of exhibition research and planning.

I am most grateful for colleagues at Bowdoin College, including Laura Premack, Michael King, Dana Byrd, Jen Jack Gieseking, and Arielle Saiber, my curricular coconspirator. I also thank Barry Mills, president of the college; Cristle Collins Judd, dean for academic affairs; S. Catherine Longley, senior vice president for finance and administration and treasurer; Megan A. Hart, legal compliance officer and assistant secretary of the college; Margaret Broaddus, senior leadership gifts officer; Grace Garland, director, corporate and foundation relations; and Ann Ostwald, director of academic budget and operations.

And, finally, I want to thank my dear friends and family for their unwavering support, especially my mother, Constance, and sisters, Rachel, Rebecca, and Laura.

SARAH J. MONTROSS
Andrew W. Mellon Post-doctoral Curatorial Fellow, Bowdoin College Museum of Art

ORBITS

OBSERVING POSTWAR ART OF
THE AMERICAS FROM OUTER SPACE

SARAH J. MONTROSS

HOW did artists imagine the future in the past? And which of the possible futures have been accounted for already? Even though the intense competition of the space race had a global impact, the study of avant-garde art inspired by space travel and futurism has largely been focused on the United States, the Soviet Union, and European countries (in other words, those countries that led postwar technological research and innovation or are perceived as originators of science fiction).[1] *Past Futures: Science Fiction, Space Travel, and Postwar Art of the Americas* expands the discussion well beyond these borders and highlights the work of artists from several Latin American countries and the United States who were profoundly inspired by the marvelous and fearsome achievements of the space age.

Past Futures presents an array of creative styles: expressionist paintings depicting mutative aliens; kinetic sculptures made of multilayered Plexiglas, suggesting parallel dimensions; meticulous graphite drawings based on National Aeronautics and Space Administration (NASA) imaging technologies; and conceptual art inspired by new wave sci-fi novels. Each of the selected artists merged the empirical languages of science and technology with their expansive imaginations to develop "visual science fictions."

This exhibition and catalogue aim to complicate the seemingly certain and universal concepts of "progress" and "the future" that are often linked with space travel. The project reveals a multiplicity of futures conceived by artists, many from Latin America, a region that has been stereotyped as primitive, folkloric, or even antitechnological. This retrograde perspective has been challenged in many previous exhibitions and publications, but *Past Futures* further unravels the notion of Latin American "backwardness" by exploring art related to the scientific imagination that exemplifies dialogues and tensions across the American continents in the years leading up to and during the Cold War. In the process, the clear dividing lines between north and south, alien and human, and past and future are cast into doubt.

Although this artwork may seem ethereal and escapist, it often directly engages with the development of inter-American relations during the postwar period. These convergences mounted during the 1960s; the United States simultaneously promoted the space program and encouraged pan-Americanist cultural and economic policies intended to unite North and South America against the spread of communism.[2] During his Special Message to Congress on Urgent National Needs of May 25, 1961, President John F. Kennedy revealed the United States' lofty goal of sending a man to the moon by the end of the decade (fig. 1). Well aware of its symbolic

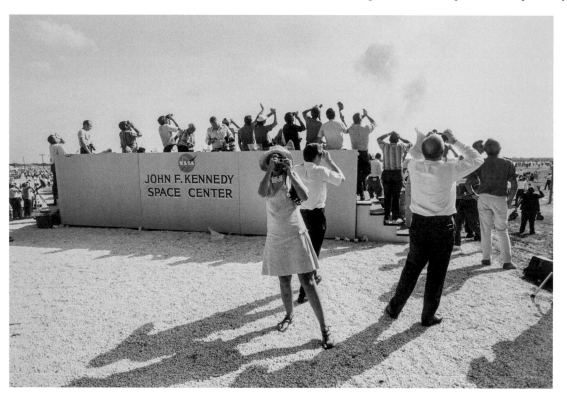

Fig. 1

GARRY WINOGRAND (American, 1928–1984)

Cape Kennedy, Florida, 1969

Gelatin silver print

11 × 13¹⁵⁄₁₆ in. (27.9 × 35.4 cm)

Bowdoin College Museum of Art, Brunswick, Maine; Gift of Michael G. Frieze, Class of 1960 (1983.29.2.1)

impact, Kennedy issued this announcement one month after the Bay of Pigs fiasco in Cuba and amid mounting antagonism from the Soviet Union and its allies (fig. 2). A few months earlier, Kennedy had introduced the ambitious Alliance for Progress program during an address before members of Congress and the Diplomatic Corps of the Latin American Republics. Just as he would outline the space program's temporal scope, Kennedy promised in this address that the United States would help establish democratic governments, improve literacy rates, promote land reform, and increase per capita income in Central and South American countries by the end of the decade as well. In introducing this program, Kennedy spoke of a common American past, present, and future in proud, utopian terms:

We meet together as firm and ancient friends, united by history and experience and by our determination to advance the values of American civilization. For this new world of ours is not merely an accident of geography. Our continents are bound together by a common history—*the endless exploration of new frontiers* (emphasis mine).[3]

Such public statements confirm art historian Andrea Giunta's observation that "after 1945, North American policies toward Latin America could be characterized by [the United States'] certainty that there was a shared geography, history, and destiny and that Latin American republics were effectively part of a natural front in the West that had to defend democracy against communism."[4] While many of the artists in this exhibition may not have agreed with this view (and some even reacted against it), these calls for Western hemispheric solidarity shaped how many exhibited, traveled, and conceived of their place in the Americas during the decades leading up to and following the space race.

Just as intergalactic journeys involve exploration into unknown territories, many of the artists in this exhibition traveled to foreign lands. Several of the Latin American artists spent periods of time in the United States and Europe, where they made art that reflected their transnational experiences, and their efforts often garnered international exposure. Most

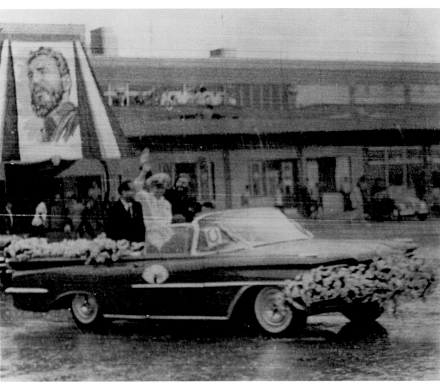

Fig. 2

Soviet cosmonaut Yuri Gagarin (center) is flanked by Cuban Prime Minister Fidel Castro and President Osvaldo Dorticós Torrado as they ride in an open car during a rainstorm. Gagarin had come to Havana for the July 26, 1961, celebration of the Cuban Revolution

of the US artists journeyed to Central and South America and created works that merged their intercontinental interactions with tropes from science fiction. Given these diverse experiences of exile and migration, the themes of extraterrestrial travel and alien encounters add metaphorical value to the art. The Czech-born philosopher Vilém Flusser, who emigrated to Brazil in 1941, described the cognitive dislocation of the migrant in science-fictional terms: distanced from one's native country, one realizes that "custom and habit are a blanket that covers over reality as it exists. . . . Discovery begins as soon as the blanket is pulled away. Everything is then seen as unusual, monstrous, and 'unsettling' in the true sense of the word. To understand this one merely has to consider one's own right hand and finger movements from the point of view of, say, a Martian. It becomes an octopus-like monstrosity."[5]

EMOGIÓN

20 MAGAZINE SEMANAL DE AVENTURAS 25

EL VENGADOR DE ATLANTIDA

POR EDMOND HAMILTON

AÑO. II NUM. 35.

Alberto Brun

EL INTERPLANETARIO ATÓMICO

REVISTA DE CIENCIA-FICCIÓN Y FANTASÍA
$10.00 MONEDA NACIONAL

minotauro

fantasía y ciencia-ficción

The Magazine of Fantasy and Science Fiction 3

contemporáneos

el libro
fantástico
de

Oaj

miguel collazo

CIENCIA-FICCIÓN

PRIMERA ANTOLOGIA DE LA
CIENCIA-FICCIÓN
LATINOAMERICANA
La narrativa más joven de todo un continente

Rodolfo Alonso Editor

Seis primeras novelas en competencia, de jóvenes escritores mexicanos. Promoción "Diógenes" 1967 - 1968

CARLOS OLVERA

Mejicanos en el espacio

EDITORIAL DIÓGENES, S.A. MÉXICO

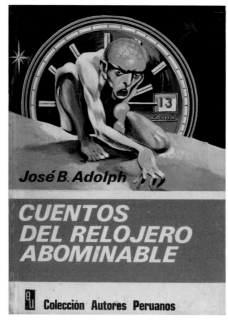

José B. Adolph

CUENTOS
DEL RELOJERO
ABOMINABLE

Colección Autores Peruanos

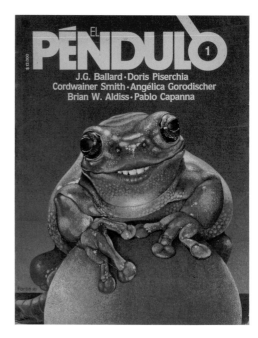

EL PÉNDULO 1

J.G. Ballard · Doris Piserchia
Cordwainer Smith · Angélica Gorodischer
Brian W. Aldiss · Pablo Capanna

The decades that this exhibition covers—1940s to 1970s—coincide with the explosive growth of the science-fiction genre in film and literature. In movies and magazines, visions of the future channeled faith in technology's ability to shape society and radically transform, and uplift, the human condition. Yet other narratives countered this idealism with expressions of anxiety about nuclear annihilation, government surveillance, and threats of dehumanization. Scholarship on science fiction from the United States is well established, but sci-fi literature from Latin American countries began to receive serious attention only in recent decades. Contributors to the field have since uncovered an incredible wealth of neglected texts (figs. 3–11).[6] Groundbreaking research projects such as *El futuro más acá: Cine mexicano de ciencia ficción* (The future's here: Mexican science-fiction film) recovered and restored many science-fiction movies and provided in-depth analysis of the idiosyncratic film industry that flourished in Mexico from the 1940s to the 1960s (fig. 12).[7]

Some science-fiction narratives from Latin America reveal distrustful attitudes toward technology, as technology was considered an imported intrusion and disruptive to the region's social fabric.[8] Mythic narratives regarding the "conquest" of the Americas and its colonial history form the backdrop of many science-fiction stories. Intergalactic expansion conducted in the pursuit of scientific knowledge or encounters with nonhuman (in other words, non-Western) aliens corresponds with constructions of colonial authority.[9]

By exposing vast discrepancies between alternative realities and one's present condition, science fiction provides ways of critiquing dominant structures of society or economic disparity within and across national boundaries.[10] As literature historian of Latin American science fiction Rachel Haywood Ferreira writes:

From the nineteenth century to the present day, science fiction has consistently proved to be an ideal vehicle for registering tensions related to the defining of national identity and the modernization process. These tensions have long been exacerbated in Latin America by the challenge of constructing and/or maintaining a national identity in the face of significant influence from the North and by the uneven assimilation of technology in Latin American countries.[11]

Haywood Ferreira's point may lead one to ask: does the uneven distribution of technological developments across the Americas also cause alternative dimensions of artistic production? Such a question helps us to frame a discussion of the artwork exhibited in *Past Futures*, which is introduced in the remainder of this essay through four broad themes. First, artists of the postwar period visualized a "new man"—a hybrid creature of human and machine—living in an age of techno-scientific innovation and changing perceptions about humankind's place in the cosmos. Second, avant-garde artists were profoundly affected by the wondrous possibilities of space travel, and they were particularly attuned to how depictions of outer space were mediated through new visual technologies. A third phenomenon explores artists' depictions of the American landscape that are superimposed with references to time travel, particularly travel to prehistoric epochs. And finally, artists engaged with one of science fiction's most enduring tropes: the

Fig. 12

Poster for the film *Conquistador de la luna* (Conqueror of the moon), directed by Rogelio A. González, Mexico, 1960

Figs. 3–11 (opposite)

Emoción: Magazine semanal de aventuras (Emotion: Weekly magazine of adventures) 2, no. 35 (August 2, 1935). Published in Mexico

Alberto Brun, *El interplanetario atómico* (The atomic interplanetary), illustrations by P. Campero (Mexico City: Editora Latino Americana, 1955)

Alejandro Jodorowsky, ed., *Crononauta: Revista de ciencia-ficción y fantasía* (Crononauta: Magazine of science fiction and fantasy) 1, 1964. Published in Mexico

Minotauro: Fantasía y ciencia-ficción (Minotaur: Fantasy and science fiction), no. 3 (January–February 1965). Published in Argentina

Miguel Collazo, *El libro fantástico de Oaj* (The fantastic book of Oaj) (Havana: Ediciones Unión, 1966)

Rodolfo Alonso, ed., *Primera antología de la ciencia-ficción latinoamericana* (First anthology of Latin American science fiction) (Buenos Aires: Colección Aventura, 1970)

Carlos Olvera, ed., *Mejicanos en el espacio* (Mexicans in space) (Mexico City: Editorial Diógenes, 1968)

José B. Adolph, *Cuentos del Relojero Abominable* (Abominable watchmaker's tales) (Lima: Editorial Universo, 1974)

El Péndulo (The pendulum), no. 1 (May 1981). Published in Argentina

All private collection

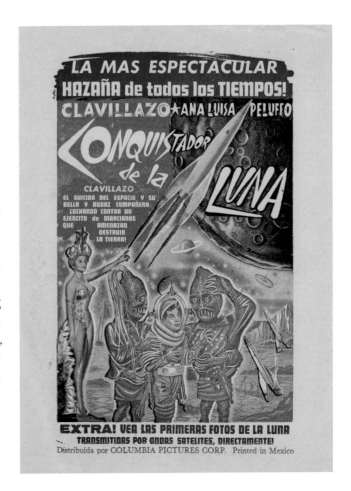

LA MAS ESPECTACULAR HAZAÑA de todos los TIEMPOS! CLAVILLAZO ★ ANA LUISA PELUFFO

CONQUISTADOR de la LUNA

CLAVILLAZO EL SUICIDA DEL ESPACIO Y SU BELLA Y AUDAZ COMPAÑERA LUCHANDO CONTRA UN EJERCITO de MARCIANOS QUE AMENAZAN DESTRUIR LA TIERRA!

EXTRA! VEA LAS PRIMERAS FOTOS DE LA LUNA TRANSMITIDAS POR ONDAS SATELITES, DIRECTAMENTE! Distribuída por COLUMBIA PICTURES CORP. Printed in Mexico

utopian or dystopian future as a reflection of hidden desires and fears of the present day.

THE CHALLENGE OF THE NEW MAN[12]

Cyborgs, aliens, and mutants—among the most enduring icons of the science-fiction genre—are metaphors for conditions of self-estrangement in a modern world. As science-fiction critic Gary K. Wolfe writes, "technology not only creates new environments for humanity, it also creates new images of humanity itself. We see ourselves reflected in science fiction's visions of robots and monsters and aliens."[13] These figures are the watchmen, warning against the consequences of unchecked genetic experimentation, atomic fallout, or unimpeded imperialism disguised as interplanetary exploration.

Encounters with these uncanny creatures also expose what lies beneath the surface of rational thought. In this way, some surrealist artists performed operations of cognitive estrangement that can be considered science fictional.[14] Chief among these practitioners is Roberto Matta.[15] On trips to New York and Mexico in the early 1940s, the Chilean artist encountered vibrant artistic communities and developed friendships with European artists in exile, including Gordon Onslow Ford and Wolfgang Paalen, with whom he nurtured deeper explorations into realms beyond the third dimension. Inspired by the Mexican landscape, particularly its volcanic terrain, his "inscapes" increasingly suggest apocalyptic scenarios (see pl. 1).

Strange humanoid figures began to inhabit his convulsive compositions in the mid-1940s. In the painting *Convict the Impossible* (1947), Matta pictured a quasi-human creature with a gaping mouth of swordlike teeth and a single eye with a dull, penetrating gaze (see pl. 2). Its head is topped by a spiky headdress that was likely inspired by pre-Columbian masks or totems. Not explicitly an alien, the figure provokes the viewer's anxious recognition. Matta spoke about the relationship between oneself and the Other as a need "to overcome the fear of feeling strange in the world, of the strangeness that is a man, a woman, a madman, a white European, a black African, a yellow- or red-skin, the stranger you are for them, the stranger that you are for yourself."[16] By the 1950s, Matta's figures acquire mechanical attributes, are equipped with threatening devices, or careen through spaces that could either be celestial or microcosmic (see pls. 6, 7, 9).[17]

Matta was a catalytic figure who profoundly influenced younger generations; he was known to have encouraged "interplanetary communication and extrasensory perception" among the young artists he mentored in New York and elsewhere. His acolytes include fellow Chileans Juan Downey and Enrique Castro-Cid. In the mid-1960s, when Downey moved from Europe to the United States, he began to carefully articulate human forms with musculature and skeletal systems connected to metal tubes and mechanical instruments (fig. 13). Downey's suite of prints *Awareness of Love* (1965) conveys the liberating possibilities of outer space, where robotic figures are released from a constricted cube (see pl. 10). *Awareness of Love* accompanied poetry by Rafael Squirru, a prominent Argentine poet who, as the

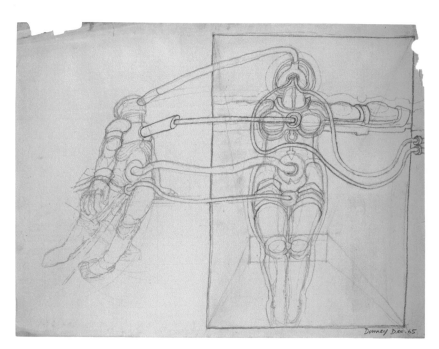

Fig. 13

JUAN DOWNEY (Chilean, 1940–1993)

Cosmonaut, 1965

Pencil and sanguine on Kraft paper

The Estate of Juan Downey

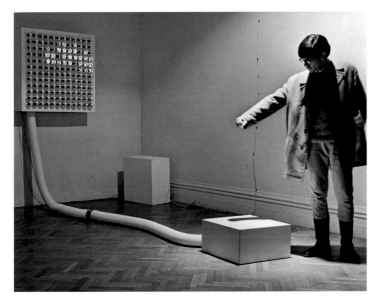

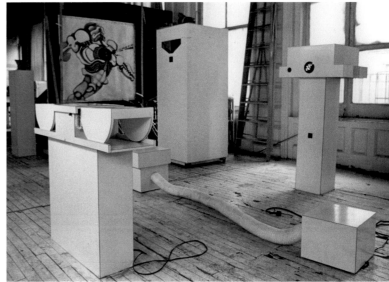

Fig. 14
Juan Downey with *Against Shadows*, 1968

Fig. 15
Juan Downey's studio in New York, c. 1969. From left to right: *Invisible Energy* (1968), *Radioactivated Chair* (1968), *Pollution Robot* (1970), and *White Box* (1968)

cultural director of the Organization of American States (OAS) from 1963 to 1970, was also a pivotal figure in inter-American cultural relations. In his writings, Squirru frequently refers to an enlightened, democratic "new man" of the Americas—reminiscent of the futuristic figures in Downey's prints—who inherited the legacies of a pre-Columbian past.

Downey subsequently created electronic sculptures and related drawings that measured and responded to electromagnetic waves, radiation, human touch, sounds, and other environmental factors (figs. 14, 15). The human form was no longer represented outright, although the presence of humanity was implied because each sculpture required activation or manipulation from participants. *Respiration and Circulation (Self-Portrait)* (1968) consisted of a pair of balloons pulsating at the rate of Downey's respiration and heartbeat, a process activated when visitors breathed

Fig. 16
Juan Downey's *Respiration and Circulation (Self-Portrait)*, 1968

onto a small plate (fig. 16). Visitors could thus experience the biological rhythms of the artist without Downey actually being present. Other sculptures encouraged focus on threads of connectivity and communication, both immediate and far-flung.[18] While a seismograph installed in one sculpture captured earthbound energies, Downey indicated that another of his devices gathered "cosmic rays, from other planets. So this piece will be done on another planet."[19]

Downey's close friend and countryman Enrique Castro-Cid also presented an expanded view of humankind in a technologically driven world. He drew pseudo-anatomical diagrams of bodies with protrusions of oversize joints or vertebrae. Bright pools of color suggest radiating inner life forces and recall the tonal splashes of Matta and Arshile Gorky. Other diagrams, such as *Blossoming Mesoamerica* (1963), represent fantastic vegetation; the title of this piece may allude to the artist's inspirational period of study in Mexico City from 1960 to 1961 (see pl. 12).

Castro-Cid moved to New York in the early 1960s, when developments in cybernetics and robotics were shifting the public's perception of the dividing line between humankind and technology.[20] In this context, Castro-Cid constructed automata in which tubes and mechanical wires facilitated bodily functions (figs. 17, 18). Arts writer Jack Burnham described the robots' curious features, noting, "These are more akin to humans divested

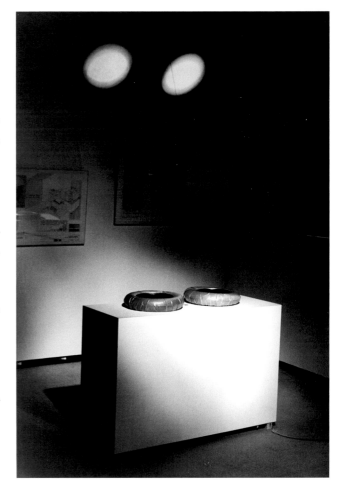

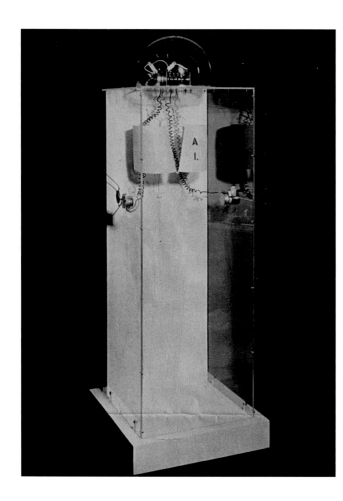

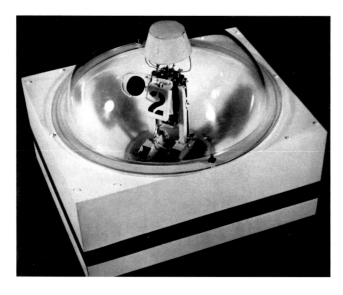

of their corporeal form, mere brains placed in bell jars with appropriate electrodes inserted, sending commands to mechanical limbs."[21] A poster for one of Castro-Cid's exhibitions at the Richard L. Feigen Gallery featured a film still of Robby the Robot from the movie *Forbidden Planet* (1956). One reviewer drew connections between Castro-Cid's playful robots and science fiction, remarking, "Much of today's science fiction depicts a bleak future where unfeeling, dominant machines enslave their human creators." Yet Castro-Cid saw his robots as an antidote to this scenario:

> They are playful, yes. I want to show machines as sympathetic. . . . In the nineteenth century the machine was considered a source of evil. Even today people talk of automation as an enemy—it will take away human jobs. But I feel very optimistic about technological development.[22]

Imbued with properties of chance and randomness, Castro-Cid's sculptures suggest an idealized society released from hierarchy and morals. While many criticized automated processes for their control over the human body and their detrimental effects on the creative process, Castro-Cid countered this perspective, stating: "Automation will produce a world without labels and destroy the moralistic concept of work. I believe in a Dionysian society."[23]

An abiding concern for humanity in the atomic age recurs in the paintings and prints of Mexican Rufino Tamayo from the 1940s onward. Paintings such as *Hombre escudriñando el firmamento* (1949; Man searching the heavens) convey the strong desire for cosmic exploration in the years leading up to the first voyages to outer space (see pl. 3). By the 1960s, Tamayo spoke about this yearning in relation to the unintended effects of technological innovation:

> Man is dehumanized in such a way that he has become a robot controlled by the computers that he himself invented. . . . This interests me greatly and I want to make interpretations of this phenomenon. . . . I think of the men who go to the moon and who are handled from the ground by electronic computers, and I feel they do not have their own will or initiative. From here [on earth] they are controlled and, in my opinion, acquire certain characteristics that are not very human.[24]

Some artists used organic materials to express a deep skepticism about techno-scientific exploration. Paraguayan Carlos Colombino's carved wood relief *Cosmonauta* (1968; Cosmonaut) offers a monstrous depiction of the "new man" of the space age (see pl. 13). This ragged semi-human creature wears a space helmet, and tentacles seem to burst from its face. Using his signature method *xylopintura*, Colombino aggressively carved, chipped, and splintered this stained wood relief to convey fierce criticism of his home country's military dictatorship, in power from 1965 to 1989. The art historian Ticio Escobar has also linked the helmet of this degraded lunar invader to that of a Spanish conquistador. Thus, this work sharply highlights not only the violence of the dictatorship and the modernist triumph of technology but also the deeper history of colonialism in Latin America.[25]

OUTER SPACE THROUGH THE LENS OF ART

During the second half of the twentieth century, few artists were as preoccupied with the idea of fantastic alien inhabitants of outer space than Argentine Raquel Forner. She began her *Moon* series in 1957, the year the

Soviets launched Sputnik, which triggered the space race between the Soviet Union and the United States. During the next four decades, while living in Buenos Aires and Paris, Forner developed many series of paintings and prints around extraterrestrial topics.

Forner's depictions of astronauts and aliens, like *Astronauta* (1964; Astronaut) (see pl. 16) convey the same expressionist anguish shown in her earlier paintings responding to the destruction caused by the Spanish Civil War and World War II. With time, her painting style became bolder and less gestural. Heavily outlined figures painted in primary colors suggest a sense of childlike wonder at cosmic encounters and share the vivid color palette seen in posters for movies such as the American sci-fi classic *Destination Moon* (1950).

Forner's astronauts and other "astro-beings," as she called them, were meant to encourage humankind to consider their fate on earth. She pointed out that "when man sees the smallness of our planet, he will realize we need to change our philosophy. There must not be so much division, not so many wars. We are all here together, we are all brothers. I hope that humanity will be better for it."[26] Forner's humanitarian message and forward-thinking subject matter were in keeping with the broader aims of the era's pan-American cultural programs and exhibitions. She received recognition from North American institutions then establishing the cultural infrastructure for space travel and was named an official artist of the Smithsonian National Air and Space Museum in Washington, DC, in the early 1970s.[27]

Astronauta y testigos, televisados (1971; Astronaut and witnesses, televised) (see pl. 15) offers an example of the type of mutant creature Forner imagined man would evolve into after spending too much time in outer space. Despite the utterly fantastic subject matter, this work also includes a standard black-and-white television set in the upper-right-hand corner of the composition, a reference to the era's ubiquitous "real-world" broadcasting of outer space exploration. After the first lunar landing in 1969, Forner recalled that friends reported that the moon they had seen on television was nothing like the one she depicted in her works. Forner responded, "I'm sorry, I saw it on television and I saw the same thing I was painting."[28]

Outer space was a realm to play out the tensions between creative acts of pure imagination and the desire to objectively render natural phenomena that had never been seen through the lens of a camera before. Forner's mutants and aliens bear no empirical relationship to the televised lunar landing, but many other artists, including Nancy Graves, Michelle Stuart, and Vija Celmins (all US-based), appropriated visual technologies used in outer space as the inspiration for new art forms. For example, Graves used lunar maps—ordered from the US Geological Survey in Washington, DC—as the basis for a 1972 painting and print portfolio that contained multiple representational languages, including pointillist abstraction and topographical surveillance imagery (figs. 19, 20, see pl. 22).

Equally fascinated by earth and sky, Celmins drafted precise depictions of the cosmos as well as desert landscapes on earth that recall lunar terrains (see pls. 20, 21). In the late 1960s, while also creating art inspired by the earth's geology (see pl. 19), Michelle Stuart created drawings and prints based on photographs of the moon's surface from NASA. Sensitive and captivating, pieces like Stuart's *Moon* (1969) focus directly downward onto the expansive lunar landscape (see pl. 17). Such visual affinities between

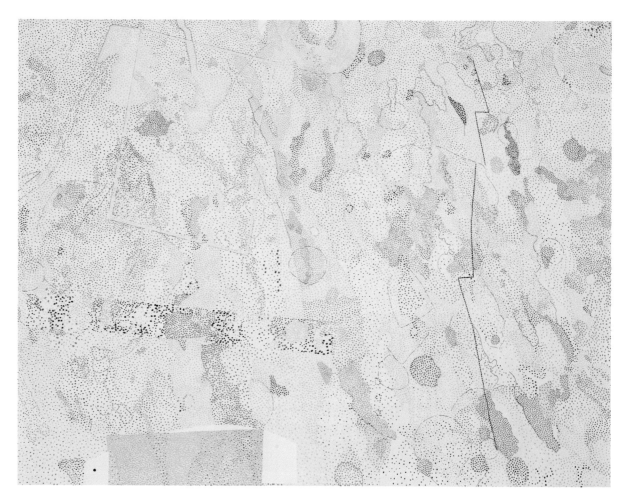

Fig. 20

Geologic map of the surface of the moon, the source for Nancy Graves's *Fra Mauro Region of the Moon*, 1972

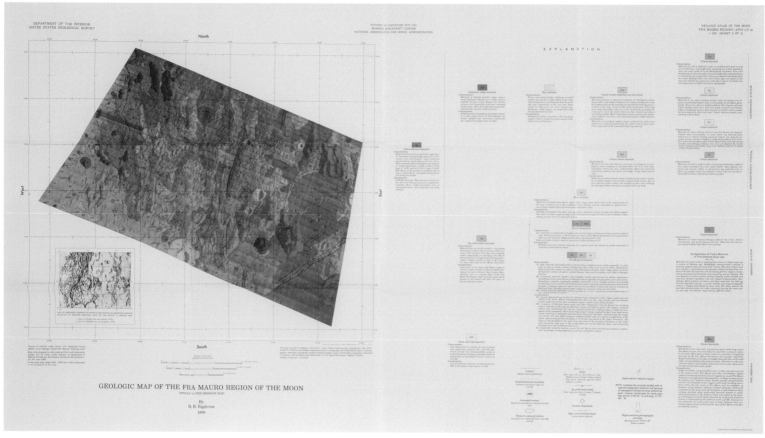

GEOLOGIC MAP OF THE FRA MAURO REGION OF THE MOON

terrestrial and lunar settings coincided with the activities of NASA astronauts who trained in the arid deserts of the American Southwest and Mexico in preparation for their missions to the moon (fig. 21).

Trained as a topographical draftsperson, Stuart added grids and notations that chart the moon's magnetic forces in some of her drawings of the satellite's surface. In other pieces, such as #7 (1969; see pl. 18), Stuart collaged small NASA photographs of the moon's surface beside hand-rendered copies.

Stuart believes that outer space is the last domain where true discovery is still possible. As she stated:

I love to read [about] the first people, you know, when they're seeing the world for the first time—a different world. A world that they don't know. I mean, it's hard to find these days. Everybody's been everywhere. But there was a time when the world was an amazing place. That may have provoked the moon drawings.[29]

Stuart's fascination with the cosmos continued to evolve with her *Nazca* series, which was inspired by a visit to the famed site of the Nazca Lines in southern Peru, where massive abstract and figurative patterns believed to correspond to constellations spread for miles across the desert. In works from the series such as *Southern Hemisphere Star Chart 1* (1981; see pl. 24), Stuart rubbed desert sand onto a rag-paper surface covered with her drawings of the desert patterns. She also inserted a row of aerial photographs of the Nazca Lines within this piece, highlighting a view of the land that is only possible for humankind through the relatively recent innovation of air travel.

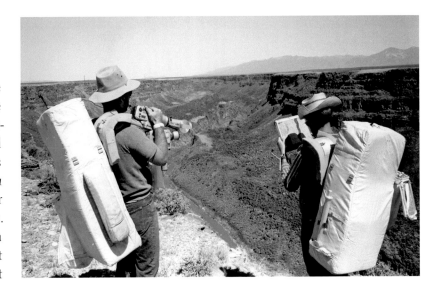

Fig. 21
Astronauts John Young (left) and Charles Duke study geology at Taos, New Mexico, September 9–10, 1971

"WHERE REMOTE FUTURES MEET REMOTE PASTS"[30]

One of the most prevalent science-fiction narratives involves characters caught in cyclical or spiraling time, temporal modes that compete with the linear and positivist progression of modern industrial achievement. This has particular relevance in the Americas, where writers of science fiction envisioned the region as a locus of prehistoric or Edenic pasts or distant, apocalyptic futures.[31] During the 1970s, some artists, particularly those associated with land art, merged their interest in alternative temporalities from science-fiction narratives with explorations of the geography and ancient cultures of Central and South America. Robert Smithson's essay "Incidents of Mirror-Travel in the Yucatan" and the related *Yucatan Mirror Displacements (1–9)* present a prime example of this convergence (see pl. 46).

Smithson, Peter Hutchinson, Dan Graham (see pl. 45), and certain artists associated with the Park Place Gallery in New York City were captivated by science fiction, especially that of new wave authors Brian Aldiss and J. G. Ballard, whose writing often featured dystopic scenarios and psychologically taut stylistic experimentation. Among these artists, Hutchinson wrote about the connections between science fiction and the art of the 1960s and 1970s. As he articulated, "much of today's new art has a science-fiction attitude. . . . It has an alien look and might have been created on another planet."[32] Notably, he established a correlation between the artist and the science-fiction writer:

Figs. 22–24

Peter Hutchinson's photo-documentation of *Parícutin Volcano Project*, 1970

When an artist makes an object and uses scientific principles, he does the same things that the science-fiction writer does with science. That is, he is being quite purposeless. His work cannot prove anything scientifically. It has no scientific use. It has neither that objective approach of science nor the reason for being science. Its accomplishments, in short, are aesthetic. As art, it is of the very best kind.[33]

With this perspective, Hutchinson created projects that blurred the boundaries between scientific inquiry and artistic practice. In 1970, he traveled to a volcano near Parícutin, Mexico, to stage an action that aimed to produce life in a place thought of as lifeless (figs. 22–24, see pl. 44).[34] Hutchinson laid down hundreds of pieces of bread in 250-foot-long lines around steaming fissures at the rim of the volcano. After six days of high humidity and intense heat at the crater's edge, the bread began to sprout spores of luminous orange mold. Hutchinson staged this pseudoscientific experiment at a remote geological formation that is often associated with the cataclysmic, primordial origins or the apocalyptic end of the earth. And while the action of growing mold mimicked the procedures of laboratory experimentation, the work ultimately did not result in the acquisition of empirical knowledge. Hutchinson's endeavor was admittedly, purposefully "purposeless" and thus liberated the tools of scientific inquiry from a methodically achieved goal.

VISIONARY BLUEPRINTS

The 1960s and 1970s are marked by a proliferation of utopian plans for social change across the Americas, including the Cuban Revolution, the spread of liberation theology, and indigenous and urban social movements. Yet the outcomes of these plans were not always positive, and some led to increased foreign intervention, heightened conflict, and repressive military governments. Some artists attempted to reconcile or even escape these tensions by creating work that imagined alternative futures and utopian scenarios. And there may be no better example of the transformation of human existence through technological innovation than Hungarian Argentine Gyula Kosice's project, *La ciudad hidroespacial* (1946–72, and ongoing; Hydrospatial city).

La ciudad hidroespacial consists of Plexiglas maquettes, pen-and-ink drawings, and written descriptions of habitats poised nearly five thousand feet above the surface of the earth (fig. 25, see pls. 28–30). In architectural diagrams, Kosice defines different areas of these living spaces

through poetic and emotional expressions of pure experience, detailing, for example, "the dream of acceptance that reality began like this" (fig. 26). The project resulted partly from the artist's frustration with the limitations of functional architecture. In a 1972 manifesto, Kosice rejected the modernist architecture and designs of the Bauhaus and Le Corbusier, in which spaces for living are "imposed on us by the compulsive need for economy in our society."[35]

Despite its otherworldly focus, *La ciudad hidroespacial* is still bound by the earthly concerns of ecological degradation and overpopulation. Kosice states, "Given the current population index, where will we be in twenty years? The population will be enormous. And where are we going to put all of these people? In the spatial city. There's no other option. Combining a great process of creativity with state-of-the-art technology, it will be possible."[36] While *La ciudad hidroespacial* appears to fit squarely within the realm of science fiction, Kosice is averse to connecting his project to the genre. Instead, he firmly believes his ideas will form "a new reality," and he even presented his project to NASA scientists in the 1980s.[37] Ultimately, the feasibility of the project is less important than Kosice's firm belief in the future as a site of unrealized and unlimited opportunity. Indeed the artist tends to favor the term *porvenirismo*,[38] which he defines as "something that is almost here—it is, literally, 'to come.'" Rather than actually reaching the future, Kosice states that "the 'almost here' is what interests me."[39]

The work of fellow Argentine Horacio Zabala starkly contrasts with Kosice's visionary plans. If *La ciudad hidroespacial* offers expansive freedom, Zabala's architectural drawings from the early 1970s of underground chambers and floating jails present conditions of confinement and isolation (fig. 27, see pl. 31).[40] The blueprint format implies that these structures are works in progress, still to be realized in a dystopian future. These scenarios echo those proposed by Zabala's countryman, sci-fi author Eduardo Goligorsky, who wrote narratives of persecution and self-isolation, such as "En el ultimo reducto" (1967; The last refuge).[41] Zabala created these drawings, which form part of his *Anteproyectos* (1972–78; Preliminary plans) series, during a period of violence, censorship, and political repression in

Fig. 25

Photomontage of Gyula Kosice's *La ciudad hidroespacial* (Hydrospatial city), 1974

Fig. 26

Descriptive diagram for Gyula Kosice's *Maquette "I," La ciudad hidroespacial* (Hydrospatial city), 1974

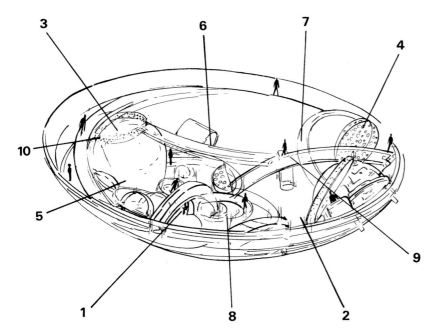

```
- Maquette I -

Places:

1) To real aloud the phantom of the Universe.

2) Place of prorogation not postponable.

3) The practical duration, now, of post-existence.

4) Place of procurement of gifts and toasts to hydroallusions.

5) The dream of acceptance that reality began like this.

6) To magnify the intermission and ethereal interrogations.

7) Place to cause the flow of currents. Induce causes obtained by that
   effect.

8) Cherishable duty in regions overwhelmed with concepts.

9) To scale the mast of absence.

10) Abstain from having a past. Re-emerge always.
```

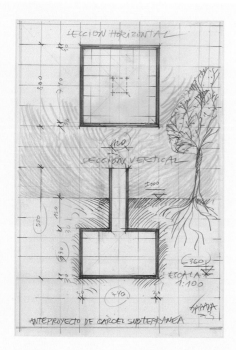 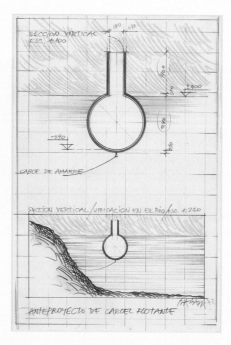 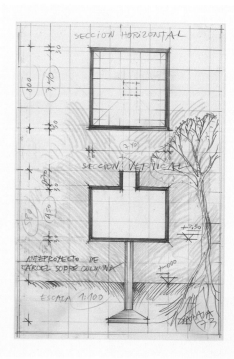

Fig. 27

Argentina, in particular, and sociopolitical upheaval shaped by neoliberal economic policies and moralizing campaigns throughout Latin America, generally.[42] Thus, these works also offer a potent metaphor for the restrictive conditions of daily life for those who did not conform to edicts issued by the Argentine government.

CONTEMPORARY RESONANCES

While focused on the decades of the 1940s to the 1970s, *Past Futures* was organized during an obvious revival of futuristic aesthetics in contemporary art of the Americas.[43] In such work, the future no longer represents unbridled possibility but is often the site of repetition or ruin instead. For the interdisciplinary project *SEFT-1* (2006–14), Mexican artist-brothers Ivan Puig and Andrés Padilla Domene constructed a futuristic vehicle and used it to travel along the passenger rail system that crosses Mexico and Ecuador (figs. 28, 29).[44] Many of these rail lines are now abandoned, following the privatization of the railway system in the 1990s. Collecting artifacts and documenting encounters with people and places along the tracks, the artists perform an archaeological investigation into the remains of a transportation system that once symbolized an optimistic future.

Argentine artist Sebastián Gordín similarly engages with retro-futurism, creating ingenious models and dioramas that recall comic book stories of alien invasions and mutant attacks. In 2003, Gordín started creating watercolors and marquetry based on the covers of pulp science-fiction magazines from the 1920s and 1930s, such as *Astounding Science Fiction* and *If*. Gordín explains why he mines this once-novel imagery:

> I look for references in materials that have been heavily used, worn out, read and re-read. Why am I looking there, where everyone has already been? Maybe because I don't feel that commitment to be a visionary, an enlightened artist who sees everything in advance. I always prefer to follow, searching through and revisiting what's been left behind, trying to look for things that have been overlooked.[45]

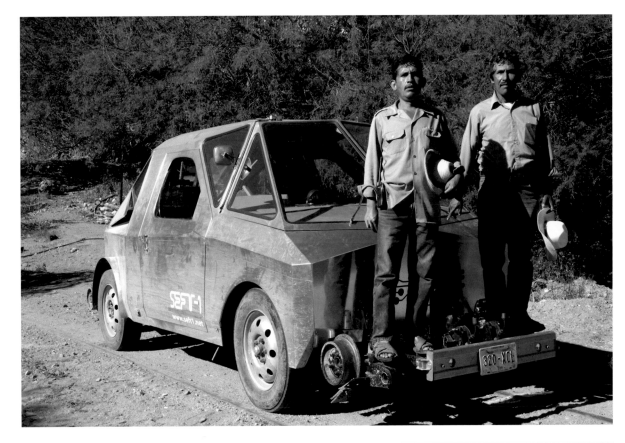

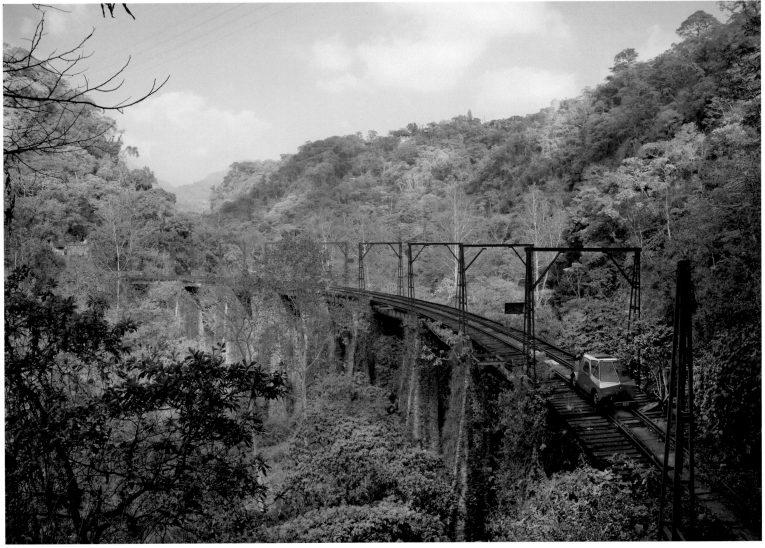

Gordín's statement clarifies a crucial distinction between much of the work presented in *Past Futures* and that by other contemporary artists who engage with the scientific imagination. Many of the artistic innovations from the postwar period became synonymous with a universal humanism and futuristic outlook that has since dissipated. Contemporary artists now turn to these tropes in order to explore themes of technological obsolescence, archival impulses, and nostalgia. Yet their work is still most effective when it combines the empirical with the imaginary. These contemporary artists are revisiting the well-trodden territories of science fiction and space travel to create entirely new meanings, which suggests that artistic practice and historical reexamination engaging these themes will continue to expand toward new frontiers.

NOTES

1 See Eugenie Tsai, "The Sci-Fi Connection: The IG, J. G. Ballard, and Robert Smithson," in *Modern Dreams: The Rise and Fall and Rise of Pop Art*, ed. Brian Wallis et al. (Cambridge, MA: MIT Press, 1988); *Art et science fiction: La Ballard connection*, ed. Valérie Mavridorakis (Paris: Musée d'Art Moderne, 2011); Lawrence Alloway, *Imagining the Present: Context, Content, and the Role of the Critic*, ed. Richard Kalina (London: Routledge, 2006); and Stephen Petersen, *Space-Age Aesthetics: Lucio Fontana, Yves Klein, and the Postwar European Avant-Garde* (University Park, PA: Pennsylvania State University Press, 2009).

2 For an excellent study of these conditions, see Claire F. Fox, *Making Art Panamerican: Cultural Policy and the Cold War* (Minneapolis: University of Minnesota Press, 2013).

3 John F. Kennedy's address to members of the US Congress and the Diplomatic Corps of Latin American Republics, March 13, 1961, in *The Cold War: A History in Documents and Eyewitness Accounts*, ed. Jussi Hanhimäke and Odd Arne Westad (Oxford: Oxford University Press, 2003), 392. For a transcript of the speech, see John F. Kennedy Presidential Library and Museum website, http://www.jfklibrary.org/Research/Research-Aids/JFK-Speeches/Latin-American-Diplomats-Washington-DC_19610313.aspx.

4 Andrea Giunta, *Avant-Garde, Internationalism and Politics* (Durham, NC: Duke University Press, 2007), 191.

5 Vilém Flusser, *The Freedom of the Migrant: Objections to Nationalism*, ed. Anke Finger, trans. Kenneth Kronenberg (Champaign: University of Illinois Press, 2003), 81–83. See also Matthew David Goodwin, "The Fusion of Migration and Science Fiction in Mexico, Puerto Rico, and the United States" (PhD diss., University of Massachusetts, Amherst, 2013).

6 The earliest examples of Latin American science fiction appear in the nineteenth century with adventure stories, such as Eduardo Ladislao Holmberg's *The Marvelous Voyage of Mr. Nic-Nac* (Argentina, 1875) and Francisco Miralles's *From Jupiter: The Curious Voyage of a Magnetized Man from Santiago* (Chile, 1878), which involve travel to other planets. Either Sebastían Camacho Zulueta or José Joaquin Mora (under the psuedonym Fósferos Cerillos) wrote a short story titled *México en el año 1970* (Mexico, 1844; Mexico in the year 1970), which described a society in which people traveled by aerostatic balloons and viewed enormous daguerrotypes more than eight meters wide. The genre emerges definitively in the mid- to late 1950s with the arrival of magazines such as *Los Cuentos Fantásticos* (Mexico, 1948–53; Fantastic stories), *Más Allá* (Argentina, 1953–57; Beyond), and *Fantastic* (Brazil, 1955–60). Prior to this, pulp magazines from the United States, such as *Famous Fantastic Mysteries* (1939–53) and *The Magazine of Fantasy and Science Fiction* (founded in 1949), were frequently translated and distributed throughout Latin America, and some of these included stories by local writers. Chilean Hugo Correa's *Los altísimos* (1959; The superior ones), and Argentine Adolfo Bioy Casares's novella *La invención de Morel* (1940; The invention of Morel) are considered among the most sophisticated examples of Latin American science-fiction writing. Works by some renowned Latin American authors, such as Jorge Luis Borges, have recently gone through a process of "retrolabeling" and are now considered science fiction. For more about this literature, see Andrea Bell and Yolanda Molina-Gavilán, eds., *Cosmos latinos: An Anthology of Science Fiction from Latin America and Spain* (Middletown, CT.: Wesleyan University Press, 2003); Aaron Dziubinskyj, "The Birth of Science Fiction in Spanish America," *Science Fiction Studies* 30, no. 1 (March 1, 2003): 21–32;

M. Elizabeth Ginway and J. Andrew Brown, *Latin American Science Fiction: Theory and Practice* (New York: Palgrave Macmillan, 2012); and Rachel Haywood Ferreira, *The Emergence of Latin American Science Fiction* (Middletown, CT: Wesleyan University Press, 2011).

7 Schmelz, Itala, ed. *El futuro más acá: Cine mexicano de ciencia ficción* (Mexico City: Difusión Cultural UNAM, Filmoteca UNAM, Landucci, 2006).

8 M. Elizabeth Ginway, *Brazilian Science Fiction: Cultural Myths and Nationhood in the Land of the Future* (Lewisburg, PA: Bucknell University Press, 2004), 4.

9 John Rieder, *Colonialism and the Emergence of Science Fiction* (Middletown, CT: Wesleyan University Press, 2008), 10.

10 See, for example, Andrea L. Bell, "The Critique of Chilean Industrialization in Hugo Correa's Avatar Stories," *Science Fiction Studies* 40, no. 2 (July 2013): 301–15.

11 Haywood Ferreira, *Emergence*, 3.

12 This subtitle comes from a collection of essays by Rafael Squirru, an Argentine diplomat who promoted inter-American solidarity during the 1960s. Squirru defined a "New Man" who achieves freedom through liberal democracy. This figure contrasts with the "hombre Nuevo" (New man) of the Cuban Revolution, who is defined by communist ideals.

13 Gary K. Wolfe, *The Known and the Unknown: The Iconography of Science Fiction* (Kent, OH: Kent State University Press, 1979), 151.

14 The term *cognitive estrangement* was coined by the science-fiction scholar Darko Suvin. It refers to the creation of alternative fictional worlds, which causes defamiliarization and comparison with one's own mundane environment, as a primary

objective of the science-fiction genre. See Darko Suvin, *Metamorphoses of Science Fiction: On the Poetics and History of a Literary Genre* (New Haven: Yale University Press, 1979).

15 After finishing his training as an architect in Chile, Matta moved to Europe in 1933, settling primarily in Paris.

16 "Pour vaincre la peur de se sentir étranger dans le monde, dans l'étrangeté qu'est un homme, une femme, un fou, un européen blanc, un noir d'Afrique, un jaune, un Peau-rouge, l'étranger que tu es pour eux, l'étranger que tu es en toi-même"; Roberto Matta, quoted in *Matta*, ed. Dominique Bozo, exh. cat. (Paris: Editions du Centre Pompidou, 1986), 308.

17 In a later interview, Matta stated, "The director who made *Star Wars*, George Lucas, filmed a scene where people from all the galaxies meet up in a bar. He told Chris Marker that he shot this scene after seeing one of my paintings in the United States." See the interview by Félix Guattari in *Matta, 1911–2011*, exh. cat. (Madrid: Sociedad Estatal de Acción Cultural, 2010), 193.

18 Juan Downey, "Electronically Operated Audio-Kinetic Sculptures, 1968," *Leonardo* 2, no. 4 (October 1969): 403.

19 Richard G. Case, "Chilean Has Unique Everson Display," *Syracuse Herald Journal*, November 22, 1971, 60.

20 Michael J. Apter, "Cybernetics and Art," *Leonardo* 2, no. 3 (July 1969): 257–65.

21 Jack Burnham, *Beyond Modern Sculpture: The Effects of Science and Technology on the Sculpture of This Century* (New York: George Braziller, 1968), 349–50.

22 Enrique Castro-Cid, quoted in Grace Glueck, "Renoir 'Robbed' Them," *New York Times*, January 17, 1965.

23 Ibid.

24 See Judith Alanís y Sofía Urrutia, *Rufino Tamayo: Una cronología, 1899–1987* (Mexico City: SEP-INBA–Museo Rufino Tamayo, 1987), 95–96.

25 Ticio Escobar, "Carlos Colombino," *Blanton Museum of Art: Latin American Collection*, ed. Gabriel Pérez-Barreiro (Austin, TX: Blanton Museum of Art, 2006), 140.

26 See Shelby Hodge, "Exploring Outer Space on Canvas," *Houston Post*, May 16, 1973.

27 Raquel Forner received many awards for her art, including the grand prize at the First American Art Biennial in Córdoba, Argentina, in 1962. During the 1950s and 1960s, art biennials and traveling exhibitions were organized across the Americas to uphold principles of Western culture and progress, and to unify the hemisphere in the face of communist aggression. See Andrea Giunta, "Strategies of Internationalization," in Giunta, *Avant-Garde, Internationalism, and Politics: Argentine Art in the Sixties* (Durham, NC: Duke University Press, 2007), 189–241.

28 See Hodge, "Exploring Outer Space."

29 See Christine Filippone, "Cosmology and Transformation in the Work of Michelle Stuart," *Woman's Art Journal* 32, no. 1 (Spring / Summer 2011): 5.

30 This phrase is from a passage by Robert Smithson: "[The present] must instead explore the pre- and post-historic mind; it must go into the places where remote futures meet remote pasts." See Robert Smithson, "A Sedimentation of the Mind: Earth Projects (1968)," in *Robert Smithson: The Collected Writings*, (Berkeley, CA: University of California Press, 1996), 113.

31 See especially Rachel Haywood Ferreira, "The Impact of Darwinism: Civilization and Barbarism Meet Evolution and Devolution," in Haywood Ferreira, *The Emergence of Latin American Science Fiction* (Middletown, CT: Wesleyan University Press, 2011), 80–129.

32 Hutchinson drew connections between references to crystallography, time travel, and alternative dimensions in works by Smithson, Larry Bell, Robert Morris, and Lila Katzen. He noted formal similarities between these artists' works and the set design from the film adaptation of H. G. Wells's *First Men in the Moon* (1964), and the writings of Norman Spinrad and Jules Verne. See Peter Hutchinson, "Science-Fiction: An Aesthetic for Science," *Art International* 7, no. 8 (October 20, 1968): 34.

33 Ibid., 32.

34 This was the same volcanic site visited by an earlier generation of artists, including Dr. Atl (pseudonym of Gerardo Murillo Cornado, Mexican, 1875–1964) and Wolfgang Paalen (Austrian-Mexican, 1905–1959), who also created work informed by themes related to the scientific imagination or space travel.

35 Gyula Kosice, "Manifesto for 'The Hydrospatial City,'" in *Kosice: Obras 1944 / 1990* (Buenos Aires: Museo Nacional de Bellas Artes, 1991), 70; also available online, see "La ciudad hidroespacial: Manifesto," Kosice official website, accessed May 28, 2014, www.kosice.com.ar/esp /resenas.php. The ideas behind the *Hydrospatial City* relate to Kosice's involvement in Madí, the pioneering constructivist art movement in Buenos Aires during the 1940s.

36 Gyula Kosice, interview with Lyle Rexer and Gabriel Pérez-Barreiro, *BOMB* (Summer 2013), accessed January 24, 2014, http://bombmagazine.org/article/7205 /gyula-kosice.

37 Gabriel Pérez-Barreiro: We are edging toward the realm of science fiction.
Gyula Kosice: No, I hate that word.
GPB: Why?
GK: Because what I am talking about is not fiction.
GPB: What would you call it then?
GK: It is a new reality—nothing more and nothing less than that, absolutely.
From *Gyula Kosice: In Conversation with Gabriel Pérez-Barreiro* (New York: Fundación Cisneros, 2012), 80–81.

38 The Spanish word for the future is *porvenir*.

39 Rexer and Pérez-Barreiro interview, *BOMB*.

40 Zabala was part of the Grupo de los 13 (Group of 13), an artists' collective associated with the Centro de Arte y Comunicación (CAYC), a multidisciplinary workshop and exhibition space in Buenos Aires. Zabala was included in the group's inaugural exhibition, *Arte y cibernética* (1969), a show that was shaped by cybernetics and systems-based processes.

41 Goligorsky writes, "My worst nightmares —which are expressed in my fiction and essays—were made real (in Argentina) between 1966 and 1983: a country degraded by oppression, violence, necrophilia, irrationality, demagoguery, and xenophobia; a country which the ultra-Right, the idiotic Left, and the chauvinist populists tried to isolate from the most fertile currents of civilized thought"; see Eduardo Goligorsky, introduction to *La ciencia ficción en la Argentina*, ed. Marcial Souto (Buenos Aires: Eudeba, 1985), 54. For English translation, see Bell and Molina-Gavilán, *Cosmos latinos*, 109.

42 A repressive military-led government was in power in Argentina from 1966 to 1973.

43 Relevant artists include Peruvians Pablo Hare and Rä di Martino and Mexicans Gilberto Esparza and Juan José Díaz Infante. The 11th Media Arts Biennale in Santiago, Chile, in 2013, featured many contemporary artists who explore intersections of art, science, and technology.

44 SEFT is an acronym for Sonda de Exploración Ferroviaria Tripulada (Manned railway exploration probe). For more about this project, see *S.E.F.T.-1*, the artists' website, http://www.seft1.net. The photograph of the SEFT-1 vehicle traveling along Metlac Bridge is a re-creation of the painting *Bridge at Metlac* (1881) by José María Velasco.

45 Exhibition wall text, *Retrospectiva de Sebastián Gordín*, Museo de Arte Moderno de Buenos Aires, Argentina, February 5–April 20, 2014.

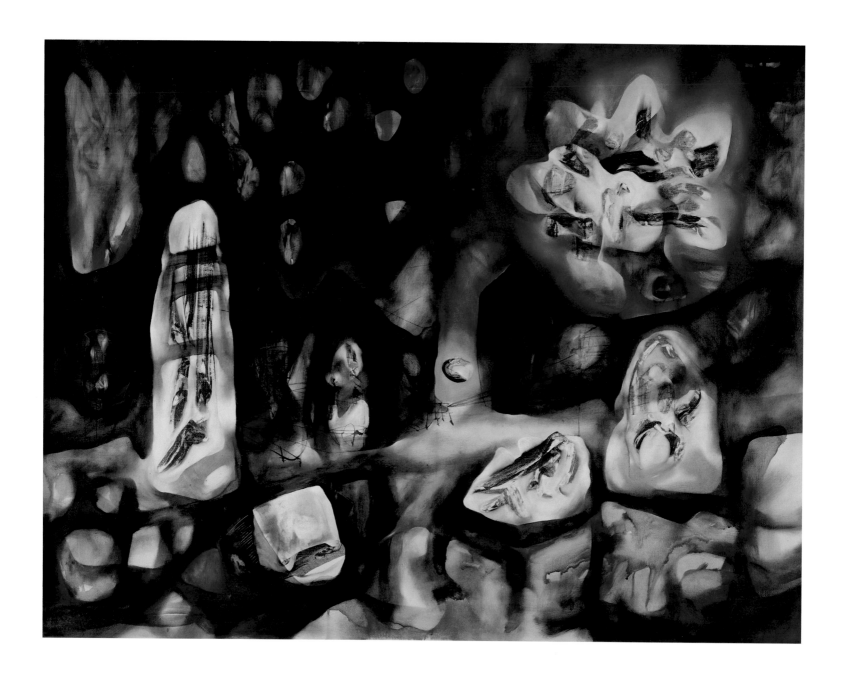

Plate 1

MATTA (Chilean, 1911–2002)

Rain: Mexico, 1941

Oil on canvas

35⁷⁄₁₆ × 46³⁄₁₆ in. (90 × 117.3 cm)

Williams College Museum of Art,
Williamstown, Massachusetts; Gift of
James Thrall Soby, Class of 1928 (50.11)

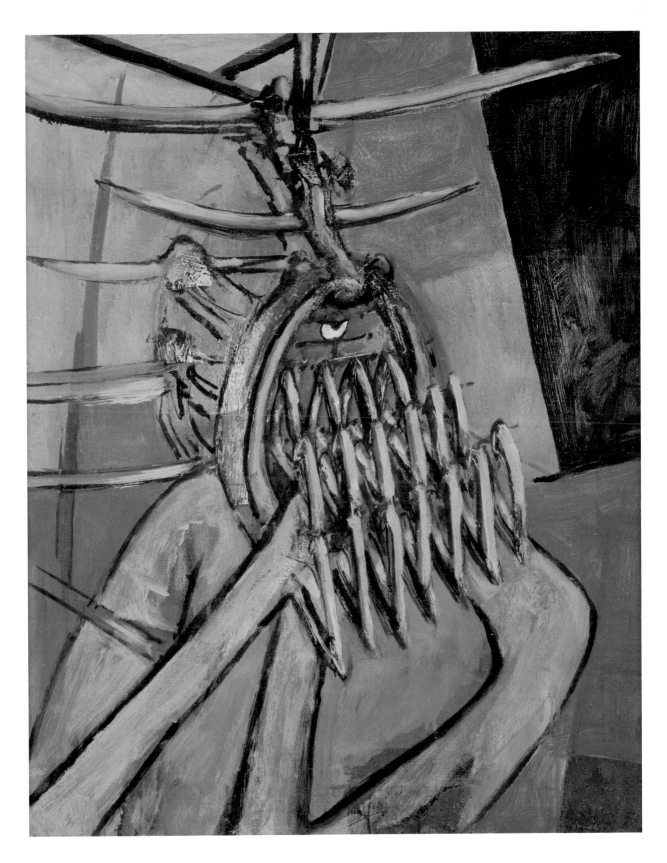

Plate 2

MATTA (Chilean, 1911–2002)

Convict the Impossible, 1947

Oil on canvas

26 × 21 in. (66 × 53.3 cm)

Private collection

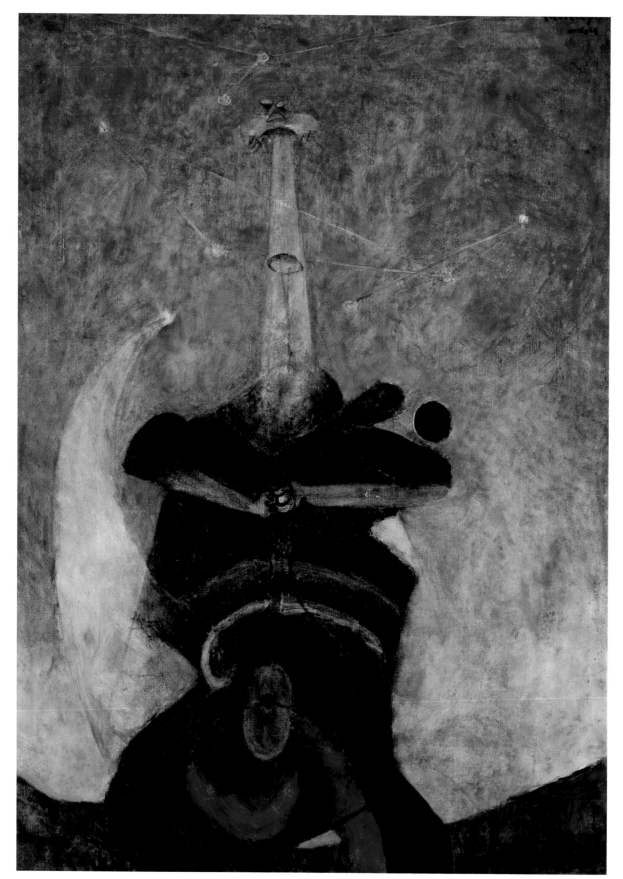

Plate 3

RUFINO TAMAYO (Mexican, 1899–1991)

Hombre escudriñando el firmamento
(Man searching the heavens), 1949

Oil on canvas

39⅜ × 27⅝ in. (100 × 70.2 cm)

Harvard Art Museums / Fogg Museum,
Cambridge, Massachusetts; Gift of
Mr. and Mrs. Harold Gershinowitz
(1978.84)

© Tamayo Heirs / Mexico / Licensed
by VAGA, New York, NY

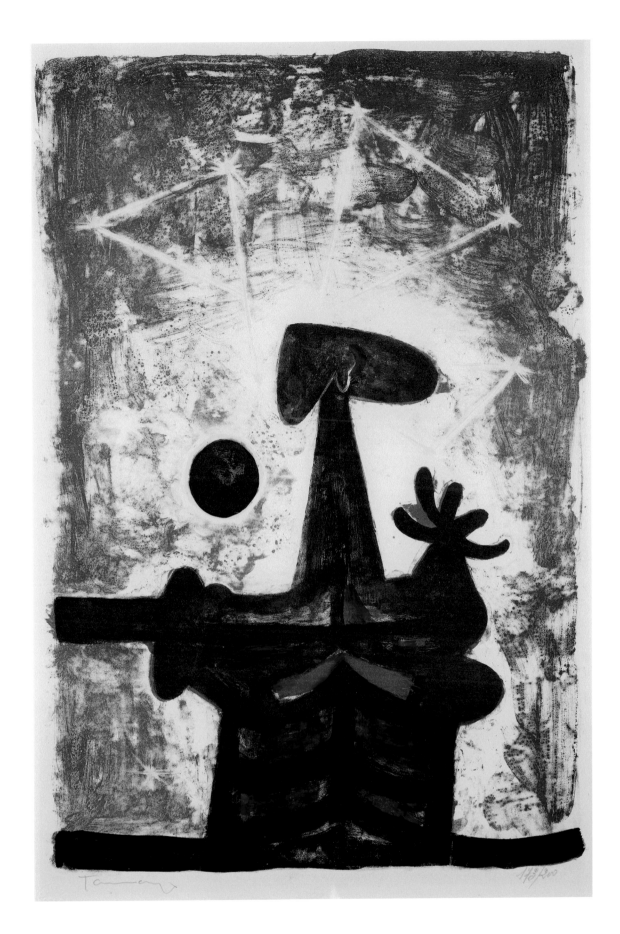

Plate 4

RUFINO TAMAYO (Mexican, 1899–1991)

Man, Moon, and Stars, 1950

Lithograph printed in color on paper

13½ × 9½ in. (34.3 × 24.1 cm)

Smith College Museum of Art, Northampton, Massachusetts; Purchased (1952.95)

© Tamayo Heirs / Mexico / Licensed by VAGA, New York, NY

Plate 5

MATTA (Chilean, 1911–2002)

Untitled, c. 1951

Oil on paper, mounted on wood panel

15½ × 23⅜ in. (39.4 × 59.4 cm)

Bowdoin College Museum of Art,
Brunswick, Maine; Bequest of William H.
Alexander, in memory of his mother
and father, Mr. and Mrs. William Homer
Alexander (2003.11.54)

Plate 6

MATTA (Chilean, 1911–2002)

L'engin dans l'éminence (The driving force of eminence), 1955

Oil on canvas

45 × 57 in. (114.3 × 144.8 cm)

Private collection

Plate 7

MATTA (Chilean, 1911–2002)

La vie est touchée (Life is affected),
1957

Oil on canvas

57 × 80½ in. (144.8 × 204.5 cm)

Yale University Art Gallery, New
Haven, Connecticut; Gift of Dr. and
Mrs. John A. Cook, BA, 1932 (1960.28)

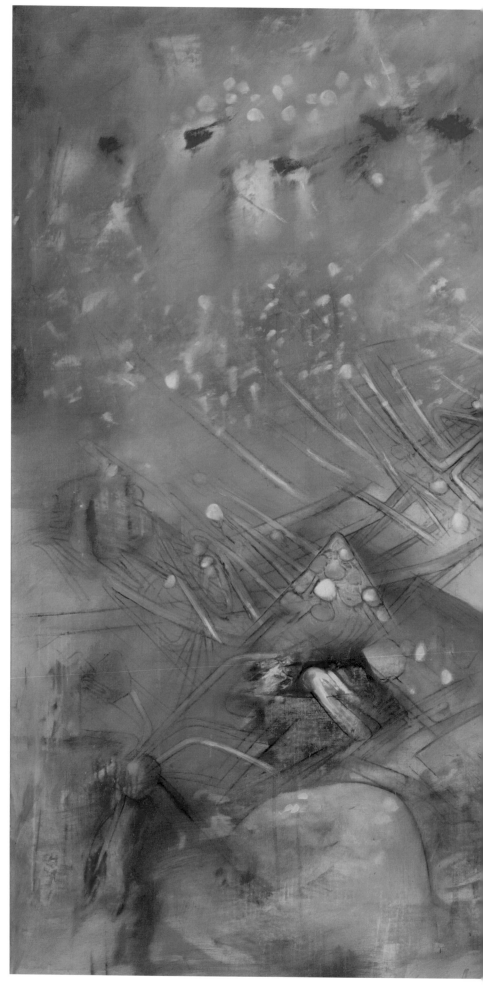

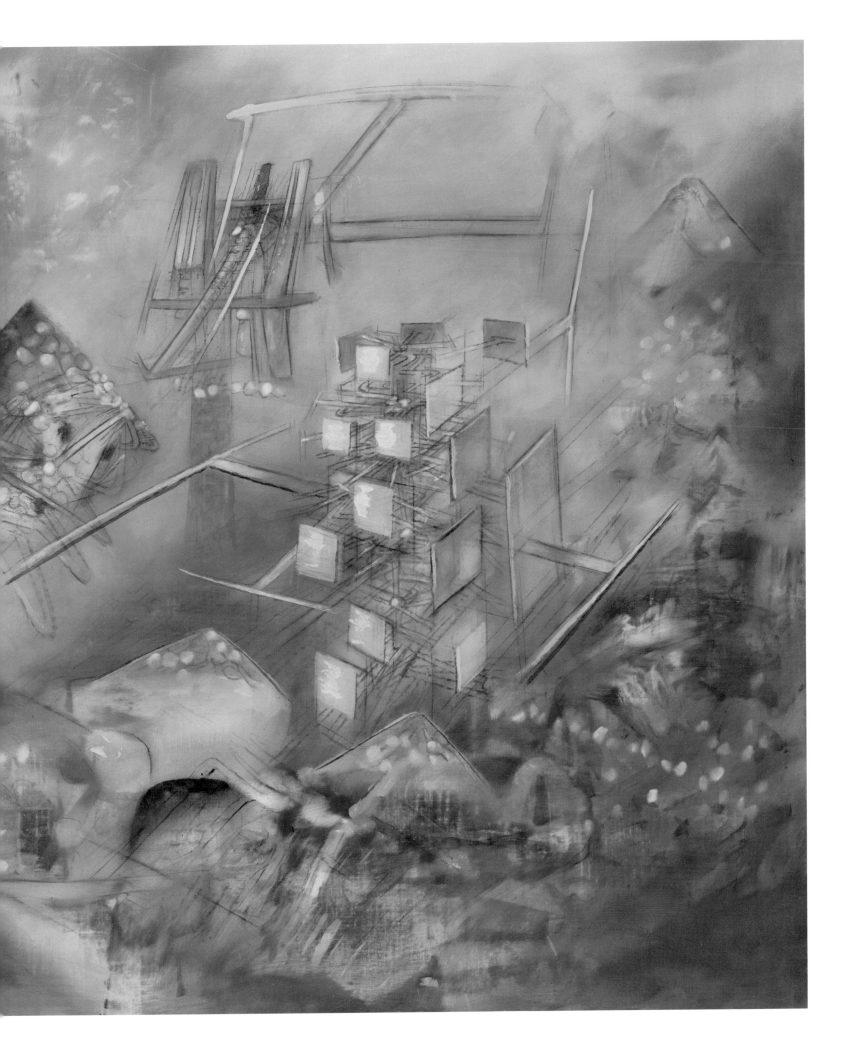

25/100 R Tamayo

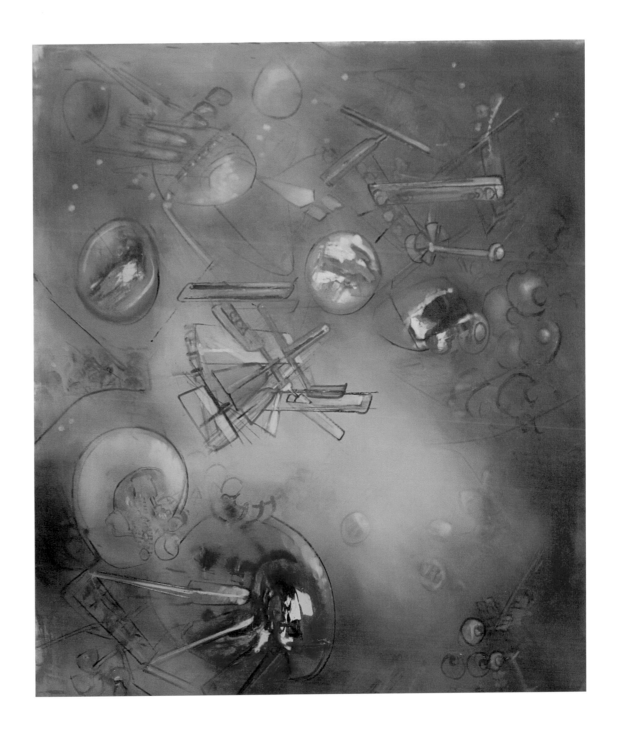

Plate 8

RUFINO TAMAYO (Mexican, 1899–1991)

Lunatic, 1958

Lithograph on paper

25¹³⁄₁₆ × 19⅞ in. (65.6 × 50.5 cm)

Harvard Art Museums / Fogg
Museum, Cambridge, Massachusetts;
Gift of Marvin Small (M13928)

© Tamayo Heirs / Mexico / Licensed
by VAGA, New York, NY

Plate 9

MATTA (Chilean, 1911–2002)

Espacio de la especie (Space of
the species), 1962

Oil on canvas

52¾ × 46¹⁄₁₆ in. (134 × 117 cm)

Private collection

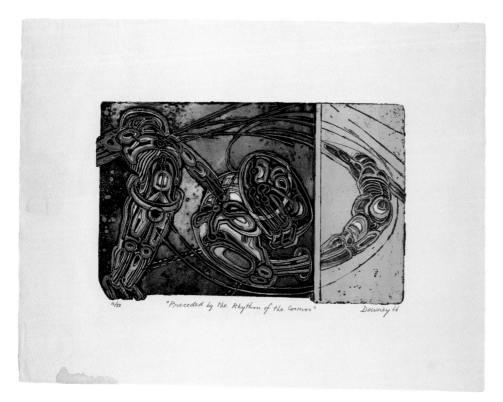

Plate 10

JUAN DOWNEY (Chilean, 1940–1993)

Preceded by the Rhythm of the Cosmos, 1966

From the portfolio of six prints *Awareness of Love*, with text by Rafael Squirru

Color intaglio on paper

22⅞ × 28¾ in. (58 × 73 cm)

The Estate of Juan Downey

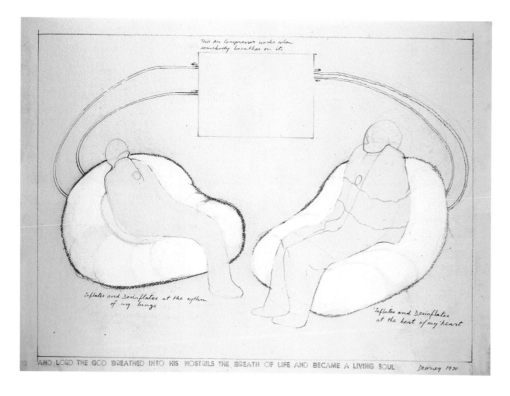

Plate 11

JUAN DOWNEY (Chilean, 1940–1993)

And Lord the God Breathed into His Nostrils the Breath of Life and Man Became a Living Soul, 1970

Colored pencil, graphite, and acrylic on paper

33¼ × 41¼ in. (84.5 × 105 cm)

The Estate of Juan Downey

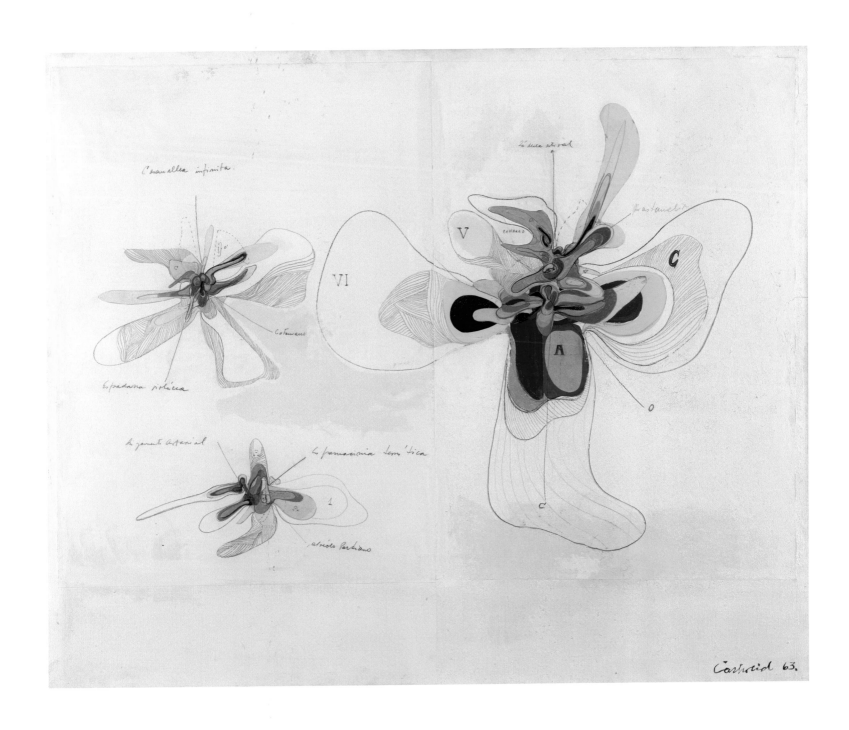

Plate 12

ENRIQUE CASTRO-CID (Chilean, 1937–1992)

Blossoming Mesoamerica, 1963

Oil and colored pencil with collage
elements on paper, mounted on canvas

30 × 37 in. (76.2 × 94 cm)

Solomon R. Guggenheim Museum,
New York; Gift, Mr. and Mrs. Robert B.
Mayer, 1963 (63.1665)

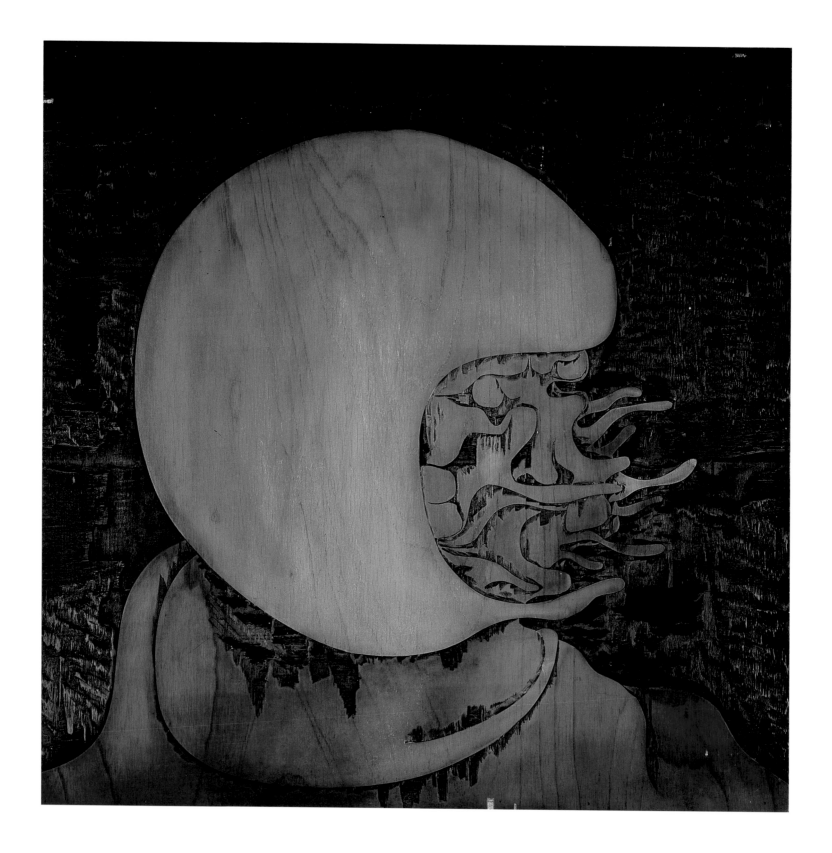

Plate 13

CARLOS COLOMBINO (Paraguayan, 1937–2013)

Cosmonauta (Cosmonaut), 1968

Oil on carved wood

39¼ × 39¼ in. (99.7 × 99.7 cm)

Blanton Museum of Art, The University of
Texas at Austin; Gift of Robert Michael,
2003 (2003.96)

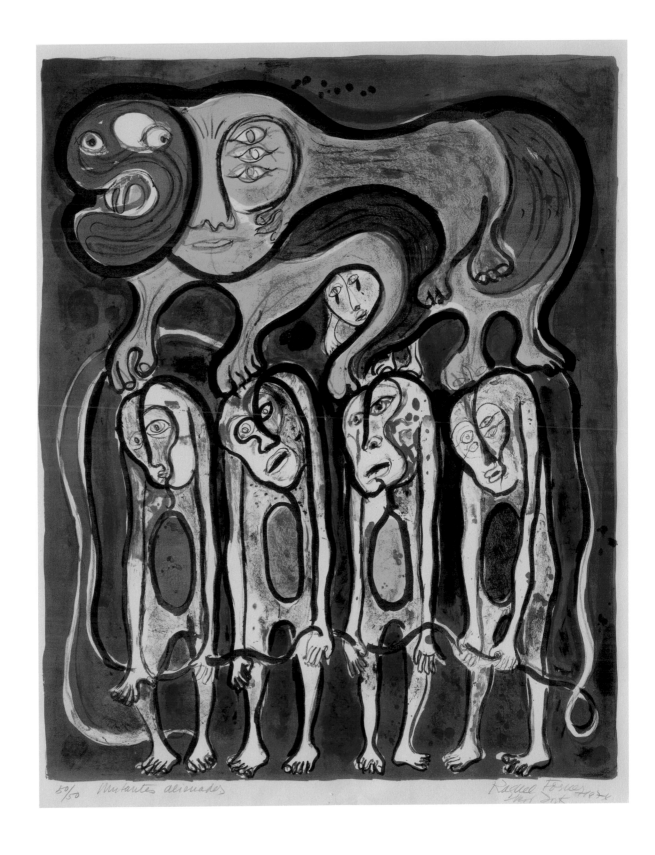

Plate 14

RAQUEL FORNER (Argentine, 1902–1988)

Mutantes alienados (Alienated mutants), 1974

Lithograph on paper

23 × 19 in. (58.4 × 48.3 cm)

OAS | Art Museum of the Americas Collection

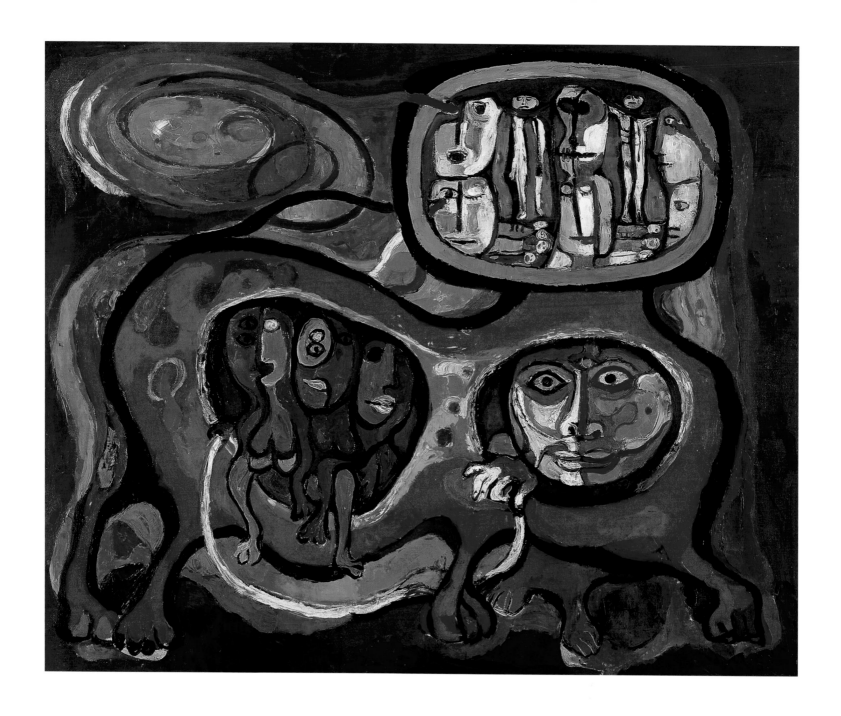

Plate 15

Raquel Forner (Argentine, 1902–1988)

Astronauta y testigos, televisados
(Astronaut and witnesses, televised),
1971

Oil on canvas

51 × 63⅜⁄₁₆ in. (129.5 × 160.8 cm)

Blanton Museum of Art, The University of Texas at Austin; Gift of Barbara Duncan, 1973 (G1973.3)

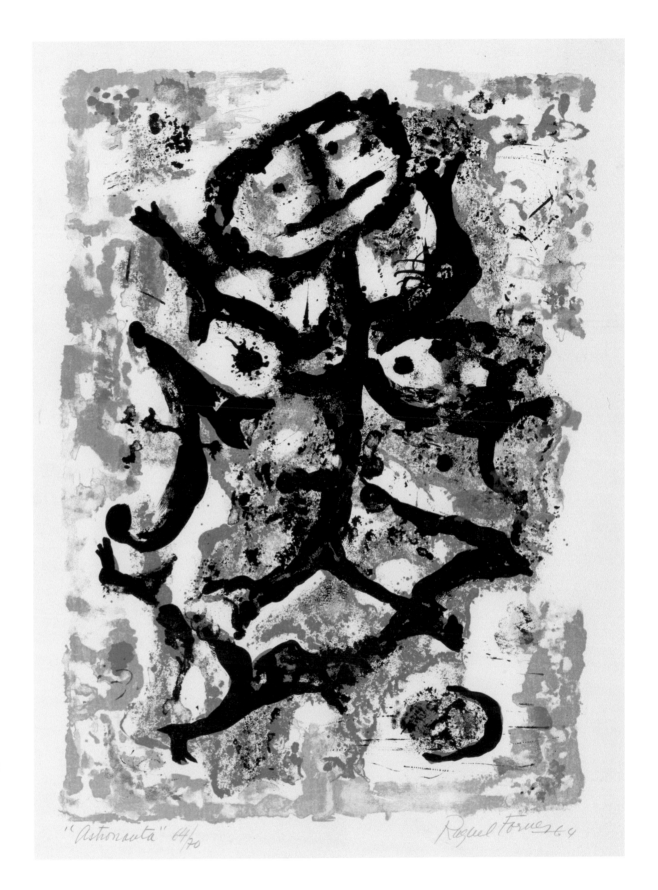

Plate 16

RAQUEL FORNER (Argentine, 1902–1988)

Astronauta (Astronaut), 1964

Lithograph on paper

21⅝ × 14³⁄₁₆ in. (55 × 36.1 cm)

Yale University Art Gallery, New Haven, Connecticut; Art Library Transfer (1978.83.2)

"Astronauta" 64/70

Raquel Forner 64

SAUDADE FOR SPACE.

UTOPIA, AND **THE MACHINE**

IN LATIN AMERICAN ART

MIGUEL ÁNGEL FERNÁNDEZ DELGADO

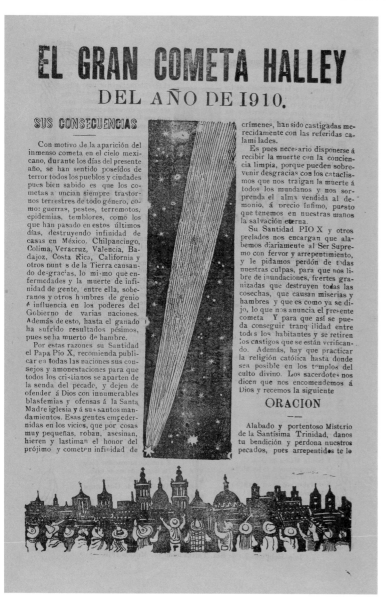

Fig. 1

JOSÉ GUADALUPE POSADA (Mexican, 1852–1913)

The Great Halley's Comet, published 1910

Double-sided relief engraving on zinc on paper

11¾ × 7¹³⁄₁₆ in. (29.9 × 19.9 cm)

Art Institute of Chicago, William McCallin McKee Memorial Endowment (1943.1254)

DURING the early colonization of Latin America, Gonzalo Fernández de Oviedo y Valdés, a sixteenth-century Spanish historian, expressed appreciation for a land that confirmed the grandeur of "God, the painter of the universe, and composer and creator of the varied colors and nuances of the multitude of his works, and of all that is contained therein and that our eyes can see."[1] Similarly inspired, most Latin American writers and artists have continued to view the world from the heights of the religious imaginary. In the last century, however, artists (particularly those discussed below), in tune with advances in human ingenuity and through the kaleidoscope of their triple cultural heritage—indigenous, European, and Latin American, following the period of independence—adapted or substituted that way of seeing for an authentic expression of what has been called Latin American baroque.[2]

Before delving into why science-fiction writing and other novel representations of the future developed in a region that has traditionally displayed greater interest in the present and the past, we must ask how Latin America has been affected by and how it has responded to changes during the last century. These same questions can be posed about Latin American visual art that is inspired by science fiction. Although exploration of this latter topic has barely begun, this essay introduces three characteristic features that may offer some answers: representations of a longing for unity in the cosmos, the continuous quest for utopia, and the ambivalent relationships between man and machine.

HARMONY WITH THE UNIVERSE

Before the arrival of European conquerors, the universe was perceived holistically in Latin American cultures, as in many other civilizations, as a whole into which human life was harmoniously integrated. The cosmos informed the Aztecs, Maya, Inca, and other native cultures of the arrival of the Europeans and the end of the world as they knew it.[3] The alignment of planets was tantamount to an announcement that the moment had come to confront one's destiny, as any singular astronomical phenomenon was thought to be a prologue to other unanticipated events, analogous to the omens that were believed to presage the arrival of the conquistadors. The idea of an animated universe never truly disappeared because, during the period of conquest, certain aspects of native and Christian cosmologies became linked—for example, the Maya moon goddess, wife of the sun god–creator, fused with the Virgin Mary.[4] Neither the cosmologies that were introduced later nor the passage of centuries managed to completely erase this sense of harmony between heaven and earth.

By the late nineteenth century, the famous printmaker and illustrator of Mexican customs, José Guadalupe Posada, created some satirical prints about anthropomorphic comets that unleash terror among a superstitious people (fig. 1). Given the political and social state of Mexico at the time, it is not surprising that the appearance of Halley's comet in 1910 seemed to predict some major event and inspired a *corrido*, or ballad, that began:

In fact, the Mexican Revolution began that November, six months after the period of the comet's greatest visibility in the middle of May. By early April, crowds of people had begun to emerge from their homes to enjoy the heavenly spectacle. In the state of Mexico, people prepared traditional food and went out to watch the comet in the early morning with their families. Those who recorded the event in their memoirs said that "the luminous phenomenon" seemed to fill the space between two important natural monuments of the Valley of Mexico: Popocatépetl, one of the most famous volcanoes in the country, and Iztaccihuatl, which is dormant.[6] Night after night, for a month and a half, Halley's presence grew, until it eventually covered nearly a fourth of the sky. At that point, the spectators' responses shifted from delight to fear, especially when news of possible catastrophes that might result from the proximity of the comet to earth was broadcast around the world. People began to believe that this was the sign of the apocalypse. Churches ordered their bells to toll, masses were celebrated, and people went out into the street to beg divine forgiveness until the comet disappeared. Then more masses were celebrated, as well as novenas of thanksgiving.[7]

One privileged witness of this historic episode was the Mexican artist Rufino Tamayo, who, at the age of ten, observed the passing of Halley's comet over several nights and mornings in his native Oaxaca. The event lived in his memory, as he mentioned in several interviews. He saw it once again in 1986, this time from his home in Cuernavaca, and by that point he was no doubt grateful to it for inspiring the comets and other astronomical phenomena that had appeared in his paintings during the past forty years.[8] Fascinated by astronomy for the better part of his life, Tamayo came to know the heavens like few other artists, as revealed by the proliferation of countless starry skies, eclipses, nebulae, satellites, and constellations outlined in geometric form in his unmistakable and imaginative artistic creations, some of which seem to illustrate Albert Einstein's general theory of relativity (see pls. 3, 4).[9] Tamayo came to see the universe as a sublime and hence intimidating spectacle, as his painting *Terror cósmico* (1954; Cosmic terror, fig. 2) suggests. However, all he had to do was think of earth as just one more element in the cosmos and "that quelled his fear."[10]

The Mexican modernist poet Amado Nervo was another great fan of astronomy. During the space race, the media recorded and repeated ad nauseam his 1917 poem, "El gran viaje" (The great journey), which begins: "Who will become, in a not too distant future,/the Christopher Columbus of some planet?"[11] *Teleguía* magazine (the Mexican equivalent of *TV Guide*)

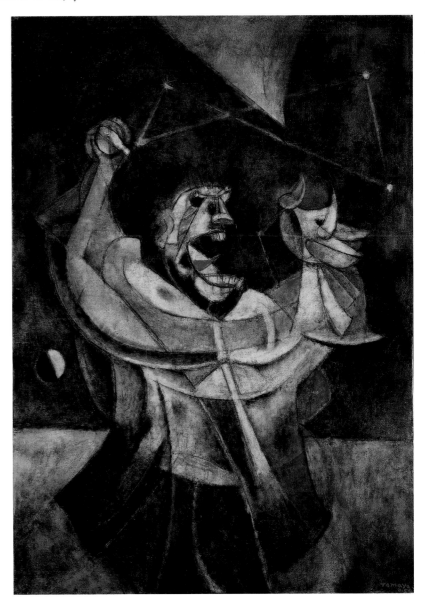

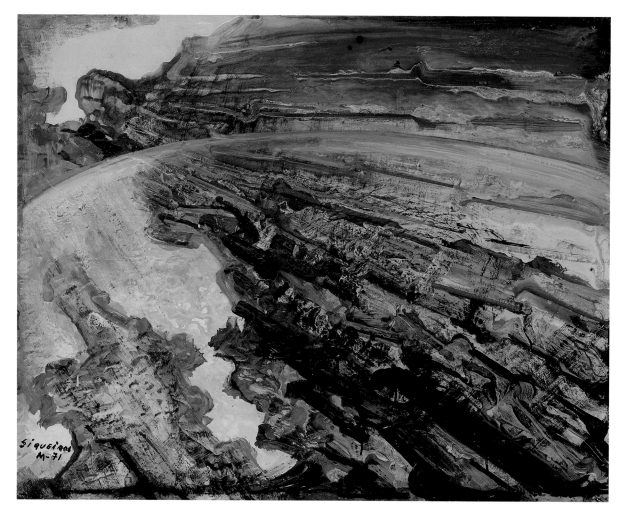

Fig. 3

DAVID ALFARO SIQUEIROS (Mexican, 1896–1974)

La tierra vista desde la estratosfera (Earth as seen from the stratosphere), 1971

Acrylic on Masonite

37¹³⁄₁₆ × 47¼ in. (96 × 120 cm)

Instituto Nacional de Bellas Artes y Literatura, Sala de Arte Público Siqueiros, La Tallera, Mexico City

devoted a special issue to the 1969 Apollo 11 lunar voyage. In the letters to the editor column, a message from a couple who had seen a Pan American World Airways' advertisement about reservations for the first commercial trips to our natural satellite appeared:

> I write to request the reservation of two tickets to travel to the Moon with my wife, when that becomes possible. My interest in getting to know that Satellite is artistic, emotional, and literary in nature. In general, my oil paintings are inspired by the places that I visit. Going into Space and touching another celestial body, is something I've always dreamed of doing. And, lastly, I am an (amateur) science fiction and travel writer.
>
> Awaiting a reply from the Boston office, I thank you for your attention,
> Víctor Romero, and wife.
> Monrovia 1105
> México 13, D. F.[12]

The Argentine Raquel Forner is among the Latin American artists who have also taken inspiration from the marvels of the cosmos. With *Lunas* (1957; Moons), Forner inaugurated the first work in what would come to be called her *Serie del espacio* (Space series). In *Astronauta* (1964; Astronaut), *Astronauta y testigos, televisados* (1971; Astronaut and witnesses, televised), and *Mutantes alienados* (1974; Alienated mutants) (see pls. 14–16), motley space fauna convey to pale earthlings passageways into an animated, colorful universe.

Similarly, with the start of the space race, the Mexican artist David Alfaro Siqueiros recognized the dawn of a new era of landscape painting:

"I think that in the age of the airplane, man can no longer hum the same tune or cling to the same romanticism about landscape as before the dominance of space exploration. This need for a cosmic landscape is part of man's new nature."[13] Perhaps photographs of our planet floating in the immense cosmos inspired him to paint *La tierra vista desde la estratosfera* (1971; Earth as seen from the stratosphere, fig. 3).

Since 1974, the Cuban-born, Mexico-based artist Mario Gallardo (Odrallag),[14] who is still actively representing the grandeur of the universe, has been painting series of multicolored suns (fig. 4), most notably, the large stained glass *Sol de América, revolución* (American sun, revolution), which he created in 1979 for the stateroom in the Cuban State Council Building in Havana, Cuba.

THE ETERNAL QUEST FOR UTOPIA

It was commonly believed that literary utopias had not been written in Ibero-American countries. However, research of the last few decades has demonstrated that utopian thought has been alive in Spanish and Portuguese writing in Latin America since the Renaissance.[15] Such themes are also present in Latin American art, and the artists themselves have designed and, at times, attempted to carry out utopian projects to reform the world around them.

Before becoming an artist, Chilean Roberto Matta graduated from the Catholic University of Chile in 1932 with a degree in architecture; his thesis proposed the creation of a "League of Religions." His plans for the project included an ecumenical temple, where followers of all religions would assemble. It would be situated in a remote location on the shores of Elefante Island in southern Chile. The most striking aspect of his plan was the design of the temple, which represented the bodies of nude women in a variety of poses.[16]

The Argentine artist Xul Solar (pseudonym of Oscar Agustín Alejandro Schulz Solari), painted a watercolor titled *Vuel villa* (1936; Flying city, see p. 78), in which we see just what the title suggests—a town or city in flight, held aloft by large balloons and propellers, an apparent homage to the Albatross, the air transport vehicle conceived by Jules Verne for his novel *Robur the Conqueror* (1886). Some twenty years after painting *Vuel villa*, Solar wrote about cities that defy gravity:

For several years someone in Buenos Aires had an outline for some project for a city, let's call it a town, where any day there might appear on the horizon, between the clouds, or any place in the air where the day before there had been nothing, a town that floats, drifts or navigates through the skies, a flying town, a "Vuelvilla," which, for short, let's call V. V.[17]

Solar's ideas resonate with that of his compatriot, the artist, philosopher, and poet Gyula Kosice, who first declared in 1944, in the single-issue magazine *Arturo*, that "el hombre no ha de terminar en la tierra" (man will not end on earth). This statement seems to foreshadow Kosice's *La ciudad hidroespacial* (Hydrospatial city), futuristic habitats that would hover thousands of feet above the earth, plans for which he outlined in a manifesto in 1972. Due to its large scale, *La ciudad hidroespacial* was intended to be built in stages, starting with a few dwellings that would be tested beforehand under the supervision of specialists (see pls. 28–30). Once built and placed in orbit, they would remain suspended in space indefinitely, like

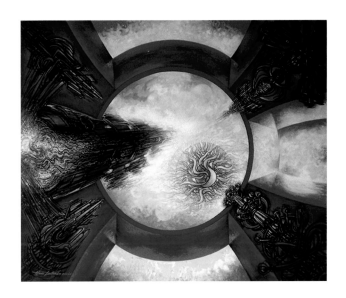

Fig. 4
MARIO GALLARDO (ODRALLAG) (Mexican, b. in Cuba, 1937)
Se abre al cosmos una nueva era (A new era opens the cosmos), 2002–6
Rendering of a ceiling mural, painted in 1977, in Havana, Cuba
Acrylic on canvas
59 × 70¾ in. (150 × 180 cm)
Collection of the artist

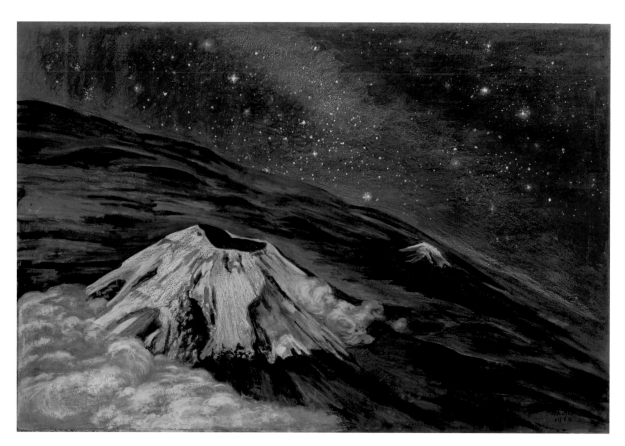

launchpads. The inhabitants of this "post-industrial work of art" would experience neither suffering nor illness; they would give new meaning to love, humor, sports, and the pleasures of the intellect—art, of course, and "as yet unexplored mental capacities."[18] Not content to imagine castles in the air, Kosice sought to share his dreams with other creative geniuses whom he admired, particularly masters of the science-fiction genre. For example, in 1980, Kosice sent a copy of his book *La ciudad hidroespacial* (1972) to Ray Bradbury.[19]

Of all the utopian projects envisioned by Latin American artists, the one that the Mexican writer and artist Dr. Atl (pseudonym of Gerardo Murillo Cornado) attempted seems by far the most ambitious. He first conceived his utopian plans, which he encouraged others to help develop, when he was living in France and the United States in the first decades of the twentieth century. He returned to these projects in the 1940s and 1950s in Mexico, where he drafted a proposal for a city that would later be called Olinka (a Nahuatl term that, according to Dr. Atl, means "where movement is produced or concentrated").[20] At Olinka, the most outstanding creative minds in all fields of knowledge would gather to develop their work free of political, social, or cultural interference. At first, he considered locating his city near Paris, but then he decided to construct it in different areas in Mexico, where he thought it would be easier to find patrons. A fan of volcanology, he considered building Olinka inside the crater of the dormant volcano at La Caldera, within the metropolitan area of Mexico City, but he eventually adjusted his original plan to allow for other settings. Essentially, the city would be comprised of a physics lab, an institute and an observatory for space research, a center for philosophic studies, and an arts studio.

As a science-fiction writer and inventor of his own cosmological theories, Dr. Atl was particularly proud of the institute at Olinka, which would be dedicated to the conquest of space. Dr. Atl believed that "freeing the

human spirit" and achieving "the final goal of human evolution" would only be possible far from earth's atmosphere (fig. 5).[21] In 1959, Dr. Atl responded to news of the first Soviet and National Aeronautics and Space Administration (NASA) space missions by announcing that accelerating his project was urgent in order to coordinate space exploration efforts at an international level. Soon after, Jacobo Königsberg, a young Mexican architect, introduced himself and offered his services, hoping to surprise Dr. Atl with his own innovative theories. Although Königsberg was not entirely convinced by Dr. Atl's ideas, he took charge of developing plans for all of the buildings, including the Center for Space Conquest, complete with launchpads, radar systems, laboratories, and design studios.[22] Dr. Atl's elitist goals and Königsberg's philanthropic ideas were ultimately irreconcilable, and the two parted ways. To the end of his days, Dr. Atl continued, in desperation, to seek support from politicians, entrepreneurs, and celebrities to carry out his dream. But he was unsuccessful; the city of Olinka was never realized.[23]

In a different sense, the desire to make the power of technology accessible to all, particularly the working class, was also utopian. The Mexican artist Diego Rivera expressed this clearly in his mural *Man at the Crossroads* (1932–34), at Rockefeller Center, which was destroyed amid controversy about its subject matter and re-created in the Palacio de Bellas Artes in Mexico City.[24] In its new location, Rivera renamed the mural *El hombre controlador del universo* (1934; Man, master of the universe), which seems partly inspired by new technology projects such as Wardenclyffe Tower, a wireless telegraph facility in Shoreham, New York, which was designed by the Serbian American inventor, engineer, and futurist Nikola Tesla.[25] Possible echoes of Tesla's tower can also be found in Siqueiros's painting *Antenas estratosféricas* (1949; Stratospheric antennae) as well as in his mural *El hombre, amo y no esclavo de la técnica* (1951; Man as master and not slave of technology), which he produced for the Instituto Politécnico Nacional in Mexico City.[26]

THE MACHINE'S MUSES AND SPECTERS

While covering the Exposition Universelle, the 1900 World's Fair in Paris, for the Mexico City newspaper *El Imparcial*, Amado Nervo wrote an article with some lines of praise for the Eiffel Tower. The monument reminded him of a majestic machine envisioned by H. G. Wells in *The War of the Worlds* (1898), and he asked, "Could this gigantic steel organism perhaps be the famous tripod where a Martian observes from his watchtower?"[27] In fact, the Brazilian Henrique Alvim Corrêa, a student of the French academic painter Édouard Detaille, was one of the first Latin American artists to contribute to the art of science fiction. In 1906, the Brussels publisher Vandamme commissioned Corrêa to create the illustrations for their edition of *The War of the Worlds* (fig. 6).

While some of the Latin American artists and writers who initially imagined the future celebrated technological advances (the "poetry of human effort,"[28] in Nervo's words), many shifted toward severe criticism of the destructive capacity of new technologies.[29] Matta demonstrated an early

Fig. 6

HENRIQUE ALVIM CORRÊA (Brazilian, 1876–1910)

Illustration for H. G. Wells, *La guerre des mondes* (The war of the worlds), translated from the English by Henry-D. Davray (Brussels: L. Vandamme, 1906). British Library, London

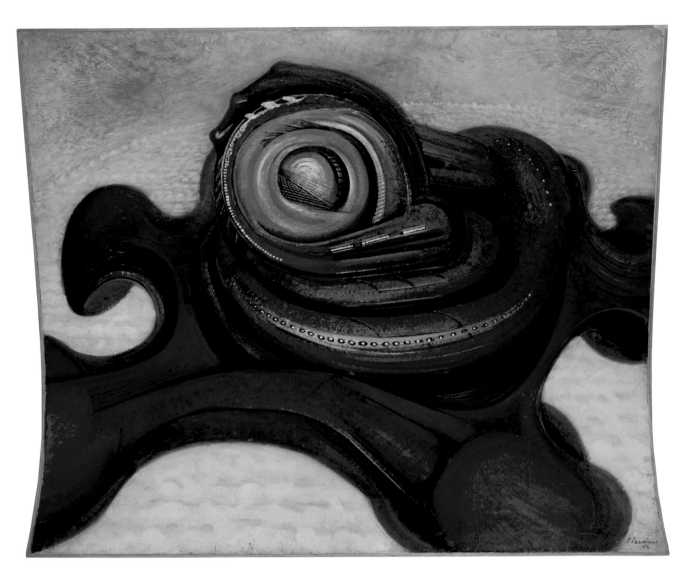

Fig. 7

DAVID ALFARO SIQUEIROS (Mexican, 1896–1974)

Aeronave atómica (Atomic aircraft), 1956

Pyroxylin on Masonite

38⅞₁₆ × 48⅛₁₆ in. (97.9 × 122.1 cm)

Instituto Nacional de Bellas Artes y Literatura, Museo de Arte Carrillo Gil, Mexico City

interest in the positive possibilities of space exploration, as reflected in his painting *Space Travel (Star Travel)* (1938), but the events of World War II seem to have redefined his attitude toward technological development. From 1942 on, he suggested these social views through figures in his art that he called *vitreurs*, totemic humanoid figures in contorted positions, and menacing mechanomorphic insect-like creatures (see pl. 2). A few years later, he emphasized the dehumanizing effect of technology and of certain social structures, reiterating his perpetual concern about chains of power that diminish human freedom in fulfillment of his own dictum, "The imagination is an eye in the center of the center."[30] The space race further tempered his faith in progress. Thereafter, his paintings abound with cosmic spaces separated by orthogonal compartments (see pl. 7). These compositions are often populated by humanoid figures, which represent chance, and machines, which symbolize efficiency and unfeeling precision (see pl. 6).[31]

We also encounter a critical ambivalence toward technology in Siqueiros's *Aeronave atómica* (1956; Atomic aircraft, fig. 7), which suggests a rational use of atomic energy,[32] and in Tamayo's work, which, beginning in 1969, includes depictions of men and women whose bodies are transformed into spacecraft. Tamayo explained this conversion by saying that "man invented the machine a long time ago, [but] today he is being displaced" by his own inventions.[33] Considering that artists could

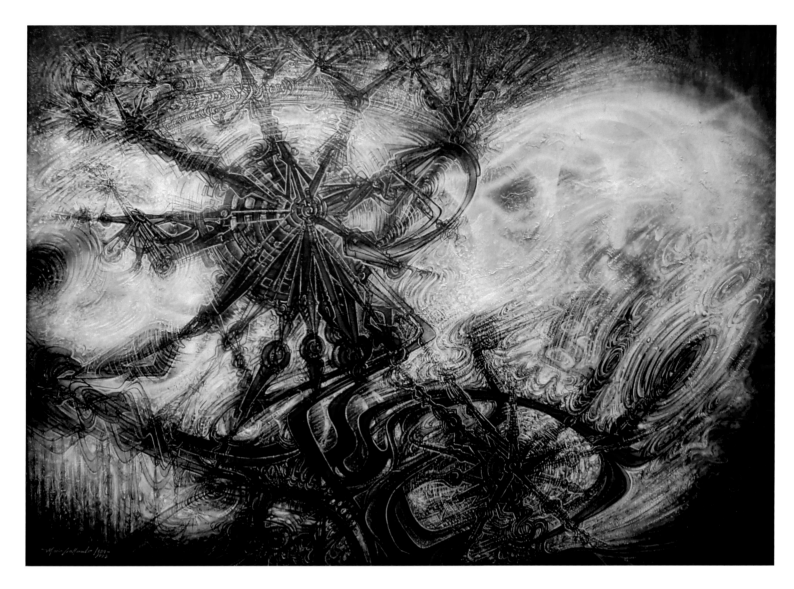

Fig. 8

MARIO GALLARDO (ODRALLAG) (Mexican, b. in Cuba, 1937)

La máquina del tiempo, homenaje a H. G. Wells (The time machine, homage to H. G. Wells), 1989–91

Acrylic on canvas

55⅛ × 78¾ in. (140 × 200 cm)

Collection of the artist

bring a unique perspective and sensitivity to the documenting of space-age achievements, NASA created an art program in 1963 and invited Matta, Tamayo, and Marcel Duchamp, among other artists, to visit its facilities.[34]

The final two artists I shall mention in this context do not appear to have lost faith in the future or the possibility of human progress. The first, Mario Gallardo (Odrallag), credits the unexpected sight of a zeppelin during his childhood in Havana as the source of his interest in drawing towers that seem to rise to infinite heights as well as spaceships and other devices that make cosmic journeys (fig. 8, pls. 40, 41). Gallardo draws and paints prodigious lines connecting these subjects to the surrounding universe. His pictures recall some verses by the Cuban poet Nicolás Guillén that are dedicated to the Sputnik satellite: "It continues traveling, it is there. With flaming tips/it leaves a perfect mark on the night."[35] In 1971, when Gallardo was awarded a bronze medal and a diploma for three drawings at the Leipzig International Exhibition on the Art of the Book, he sent a letter and a signed drawing with a dedication to Ivan Efremov, the author of *The Andromeda Nebula*, one of the most renowned Soviet science-fiction novels, in gratitude for the utopian ideas that had inspired his artwork.[36]

Another avid reader of science fiction, Mexican artist Manuel Felguérez[37] creates work that represents one of the most evident synergies between technology and art. Between 1969 and 1973, he directed and participated actively in an experimental workshop later called El espacio

múltiple (1978; Multiple space), in which, according to Felguérez, geometry was the "center of the artistic task."[38] He later explored the notion that geometry could be manipulated by means of a computer. He initiated an experiment to create computer-generated designs consistent with his abstract painting style. Thanks to a Guggenheim Fellowship in 1975, he continued the project at Harvard University, where he collaborated with systems engineer Mayer Sasson. A selection of these computer-generated designs formed compositions for a series of paintings called *La máquina estética* (1983; The aesthetic machine),[39] which he felt asserted the notion that "it was possible to provide the computer with an artificial sensitivity."[40]

When it comes to science fiction and representations of the future, Latin American artists have generally preferred to celebrate the marvels of the world and to extol the most sublime human creations and ideas, but without forgetting to call attention to potential misuses. They are generally pacifists who measure the value of technological invention for their possible benefits for humanity, and who celebrated the space race because they thought that it represented not only an unprecedented opportunity to discover and enter into harmony with the universe but also the first step toward cooperation and worldwide peace.

By way of conclusion, we can say that, like the majority of Latin American science-fiction authors, these artists do not cling to the past nor tolerate conservative ideas opposed to change. Following the terminology introduced by Karl Mannheim in his proposal for a sociology of knowledge,[41] we can say that they do not belong, generally, to the social groups that defend ideology, which is the false conscience that legitimates reality and figures of authority. They are affiliated with another conception, the utopia, which can be both an evasion and an alternative to established power. For these reasons, some of these artists participate, even as activists, with left-wing movements or political parties, whereas others consider themselves non-political. For example, Matta, who did not consider himself a painter but a creator or inventor,[42] formulated the following definition: "Art is the desire of what doesn't exist, and simultaneously the tool to fulfill such desire."[43]

Of all the artists we have mentioned, three are still living and active (Kosice, Felguérez, and Gallardo), but all of them, like the subsequent generations, are quite sure of a future that is full of surprises. They assert that the inner spaces of the mind, the earth's surface, its orbit and atmosphere, and interstellar space are all places to develop their creativity, and, last but not least, that the world will continue to be a site full of color and poetry.

Translated from the Spanish by Janice Jaffee.

NOTES

In the title of this essay, *saudade*, the untranslatable word of Portuguese origin, which is also used in Spanish, refers to the melancholic longing or nostalgia for a person, place, or thing that is far away.

1 "Dios pintor del mundo e componedor e criador de las diversas colores e matices de la multitud de sus obras, e de todo lo que contiene e de que nuestra vista puede ver"; see Gonzalo Fernández de Oviedo y Valdés, *Historia general y natural de las Indias*, vol. 4, ed. Juan Pérez de Tudela y Bueso (Madrid: Atlas, 1992), 331.

2 Alejo Carpentier and José Lezama Lima introduced the term *Latin American baroque* to refer to the mix of native cultures with European baroque. The style is characterized by the exuberance of nature, the hybridity of miscegenation, and the influence of African culture. See Alejo Carpentier, *Tientos y diferencias* (Buenos Aires: Calicanto, 1976); and José Lezama Lima, "La curiosidad barroca," in Lezama Lima, *Confluencias* (Havana: Letras Cubanas, 1988), 214–41.

3 Leopoldo Zea, ed., *Ideas y presagios del descubrimiento de América* (Mexico City: Fondo de Cultura Económica, Instituto Panamericano de Geografía e Historia, 1991).

4 Anthony F. Aveni, *Conversing with the Planets: How Science and Myth Invented the Cosmos* (Boulder: University Press of Colorado, 2002), 104.

5 "Cometa, si hubieras sabido / lo que venías anunciando, / nunca hubieras salido / por el cielo relumbrando"; Vicente T. Mendoza, *El corrido de la revolución mexicana* (Mexico City: INEHRM, 1956), 27–28.

6 Rutilo Galicia Espinosa, *El almacén de mis recuerdos* (Mexico City: INEHRM, 1997), 19.

7 Ibid.

8 Norma Ávila Jiménez, *El arte cósmico de Tamayo* (Mexico City: Praxis, UNAM, 2010), 23–27.

9 Ávila Jiménez, *El arte cósmico de Tamayo*, 116–23; Rita Eder, "El espacio y la posguerra en la obra de Rufino Tamayo," in *XIX Coloquio internacional de historia del arte: Arte y espacio*, ed. Óscar Olea (Mexico City: Instituto de Investigaciones Estéticas, UNAM, 1997), 243–44.

10 Ávila Jiménez, *El arte cósmico de Tamayo*, 110.

11 "¿Quién será, en un futuro no lejano, / el Cristóbal Colón de algún planeta?"; Amado Nervo, *Obras completas*, 2 vols. (Mexico City: Aguilar, 1991), 2: 1787–88.

12 "La Conquista de la Luna," *Teleguía*, special edition, June 16–24, 1969.

13 Miguel Ángel Fernández Delgado, "Siqueiros y la necesidad del paisaje cósmico," in *Siqueiros Paisajista*, ed. Itala Schmelz and Ana Echeverri (Mexico City: Conaculta, 2010), 84.

14 When cited, the artist prefers that the letters of his surname appear in reverse order.

15 Jean-Pierre Étienvre, ed., *Las utopías en el mundo hispánico / Les utopies dans le monde hispanique* (Madrid: Casa de Velázquez; Madrid: Universidad Complutense, 1990).

16 *Exposición Matta uni verso*, Ministerio de Educación de Chile, Ministerio de Educación de Venezuela (Santiago: Museo Nacional de Bellas Artes, 1992), 17.

17 "Alguien en B. Aires tenía, ya desde varios años algún proyecto en boceto, de una ciudad, digámosla villa, que cualquier día podría presentarse sobre el horizonte, asomarse por entre las nubes, aparecer en cualquier lugar del aire donde no había nada el día antes, es decir una villa que flote, derive o navegue por los aires, una villa volante, una Vuelvilla, que por brevedad llamemos V.V."; see Xul Solar, "Vuelvilla," undated text, c. 1959–60, Documentary Archives of the Fundación Pan Klub-Museo Xul Solar, Buenos Aires, quoted in Patricia M. Artundo, "El libro del cielo: Cronología biográfica y crítica," in *Xul Solar*, ed. Marcos-Ricardo Barnatán (Madrid: Museo Nacional Centro de Arte Reina Sofía, 2002), 217–18.

18 See "Manifesto Madí," Kosice official website, accessed June 10, 2014, www.kosice.com.ar/esp/la-ciudad-hidroespacial.php.

19 See "La ciudad hidroespacial: Manifesto," Kosice official website, accessed May 28, 2014, www.kosice.com.ar/esp/resenas.php.

20 Cuauhtémoc Medina González, "Una ciudad ideal: El sueño del Dr. Atl" (thesis, UNAM, 1991), 108.

21 Dr. Atl's ideas on this topic are concentrated primarily in Dr. Atl, *Un hombre más allá del universo* (Mexico: Ediciones Botas, 1935).

22 Jacobo Königsberg, *Olinka: Ciudad ecuménica* (Mexico City: Cuadernos de Teoría y Visión, 1967).

23 For the description of Dr. Atl's project, I rely mainly on Medina González, "Una ciudad ideal."

24 In 1933, Rivera was commissioned to paint a mural at Rockefeller Center representing scientific progress. He included a portrait of Vladimir Lenin as one of the leaders of future workers. The patron, John D. Rockefeller, requested that Rivera remove Lenin's face, but the artist refused. Rivera was

not allowed to finish the mural, which was subsequently destroyed. See Gerry Souter, *Diego Rivera* (Slovenia: Korotan Ljubljana, 2012), 176, 178.

25 Robert Linsley, "Utopia Will Not Be Televised: Rivera at Rockefeller Center," *Oxford Art Journal* 17, no. 2 (1994): 48–62; and *Nikola Tesla on His Work with Alternating Currents and Their Application to Wireless Telegraphy, Telephony, and Transmission of power: An Extended Interview*, ed. Leland I. Anderson (Breckenridge, CO: Twenty-First Century Books, 2002).

26 Fernández Delgado, "Siqueiros y la necesidad del paisaje cósmico," 87–88.

27 Nervo, *Obras completas*, 2:1441.

28 Nervo, *Obras completas*, 1:973.

29 Ibid.

30 Carmen Hernández, "Roberto Matta: Viaje hacia la consciencia," in *Matta: Mattamorfosis en Viña* (Viña del Mar, Chile: Municipalidad de Viña del Mar, 1999), 62.

31 Damián Bayón, "Matta: Un original inventor de signos," in *Matta: Mattamorfosis en Viña* (Viña del Mar, Chile: Municipalidad de Viña del Mar, 1999), 12–14; and Anne Tronche, "Les grands transparents," *Fiction* 156 (November 1966): 151–52.

32 Fernández Delgado, "Siqueiros y la necesidad del paisaje cósmico," 88.

33 Ávila Jiménez, *El arte cósmico de Tamayo*, 55.

34 Ibid., 48–52; Vincent Di Fate, "A Cape Canaveral Diary," *Analog Science Fiction & Fact*, August 1992, 58.

35 "Todavía viaja, está allí. Con encendidas puntas / deja en la noche una impecable estría"; see Nicolás Guillén, *Sputnik 57*, illustrations by Mario Gallardo (Havana: Ediciones Unión, 1980).

36 Mario Gallardo, interviews by the author, April 28 and May 3, 2014.

37 See Manuel Felguérez, Dore Ashton, et al., *Manuel Felguérez: Constructive Invention* (Mexico City: INBA, CONACULTA; Barcelona: Editorial RM, 2009), 206.

38 Elisa García Barragán, "Manuel Felguérez: Pintor del alma de la ciencia," in *Ciencia y Desarrollo* 19, no. 109 (March–April, 1993): 86.

39 Manuel Felguérez and Mayer Sasson, *La máquina estética* (Mexico City: UNAM, 1983).

40 Felguérez and Sasson, *La máquina estética*, 7.

41 Karl Mannheim, *Ideología y utopia* (Mexico City: Fondo de Cultura Económica, 1987); and the important revision of this work by Paul Ricoeur, *Ideología y utopia* (Mexico City: Editorial Gedisa Mexicana, 1991).

42 Quoted by Nemesio Antúnez Zañartu, "Matta," in *Exposición Matta uni verso: Ministerio de Educación de Chile, Ministerio de Educación de Venezuela* (Santiago: Museo Nacional de Bellas Artes, 1992), 52.

43 "El arte es el deseo de lo que no existe, y a la vez la herramienta para realizar ese deseo"; see Antúnez Zañartu, "Matta."

Plate 17

MICHELLE STUART (American, b. 1933)

Moon, 1969

Graphite on paper

24 × 24 in. (61 × 61 cm)

Leslie Tonkonow Artworks + Projects,
New York, NY

62

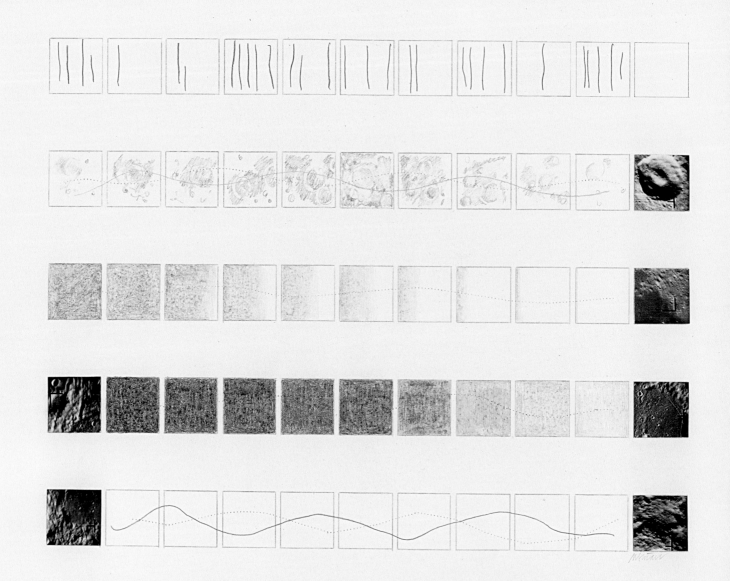

Plate 18

MICHELLE STUART (American, b. 1933)

#7, 1969

Graphite, colored pencil, and black-
and-white photographs on paper

23½ × 27⅞ in. (59.7 × 70.8 cm)

Leslie Tonkonow Artworks + Projects,
New York, NY

Plate 19

MICHELLE STUART (American, b. 1933)

Little Moray Hill, 1973

Graphite on paper

8 × 10 in. (20.3 × 25.4 cm)

Bowdoin College Museum of Art,
Brunswick, Maine; Museum Purchase,
Greenacres Fund (2011.12)

28/80

V. Celmins

Plate 20

VIJA CELMINS (American, b. in Latvia, 1938)

Comet, 1992

From the *Skowhegan* suite

Linoleum cut on Fabriano
Tiepolo paper

14 5/16 × 16 3/4 in. (36.4 × 42.6 cm)

Bowdoin College Museum of Art,
Brunswick, Maine; Bequest of David P.
Becker, Class of 1970 (2011.69.102)

Plate 21

VIJA CELMINS (American, b. in Latvia, 1938)

Desert, 1971

Lithograph printed in three grays on
Arches paper

22½ × 29¼ in. (57.2 × 74.3 cm)

Smith College Museum of Art,
Northampton, Massachusetts;
Purchased (1972.38-1)

Part of Sabine D. Region, Southwest Mare Tranquilitatis

Fra Mauro Region of the Moon

Montes Apenninus Region of the Moon

Maskelyne DA Region of the Moon

Sabine DM Region of the Moon

Riphaeus Mountains Region of the Moon

Maestlin G Region of the Moon

Julius Caesar Quadrangle of the Moon

Sabine D Region of the Moon, Lunar Orbiter Site IIP-6 Southwest Mare Tranquilitatis

Geologic Map of the Sinus Iridum Quadrangle of the Moon

Plate 22

NANCY GRAVES (American, 1939–1995)

From the series *Lithographs Based on Geologic Maps of Lunar Orbiter and Apollo Landing Sites*, 1972

Ten lithographs

22 × 30 in. (55.9 × 76.2 cm) each

Harvard Art Museums / Fogg Museum, Cambridge, Massachusetts; Gift of Anne MacDougall and Gil Einstein in honor of Marjorie B. Cohn (M26547)

© Nancy Graves Foundation, Inc. / Licensed by VAGA, New York, NY

Page 70: Nancy Graves, *Montes Apenninus Region of the Moon* (detail), 1972

Page 71: Nancy Graves, *Maestlin G Region of the Moon* (detail), 1972

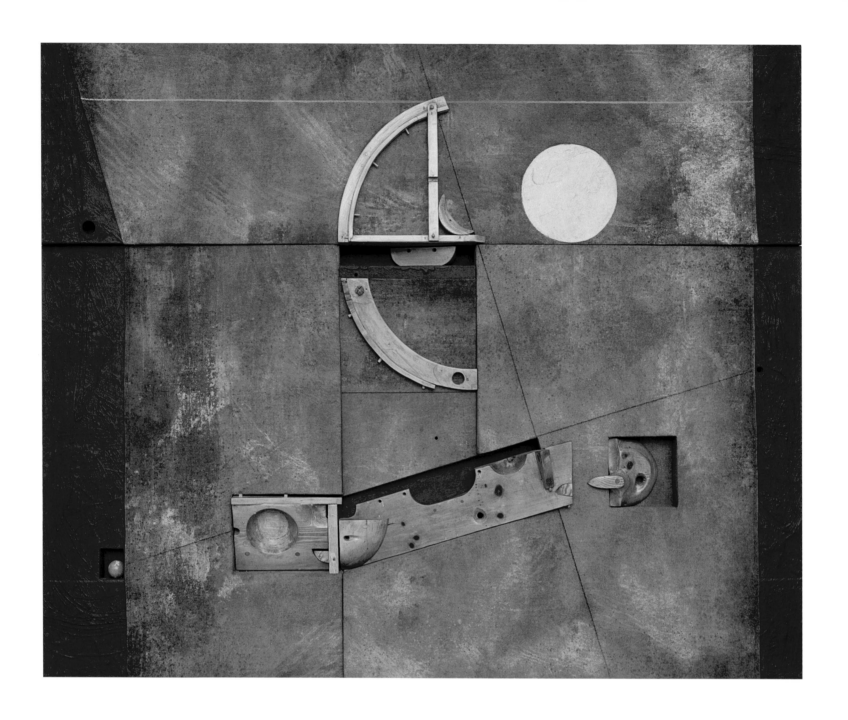

Plate 23

MARCELO BONEVARDI (Argentine, 1929–1994)

The Supreme Astrolabe, 1973

Painted construction

70¼ × 87 in. (178.4 × 221 cm)

Solomon R. Guggenheim Museum, New York; Gift, The Dorothy M. Beskind Foundation, 1973 (73.2057)

Plate 24

MICHELLE STUART (American, b. 1933)

Southern Hemisphere Star Chart I,
1981

From the *Nazca* series

Earth from the Nazca Plateau, Peru,
graphite and black-and-white photo-
graphs on paper

32 × 40 in. (81.3 × 101.6 cm)

Leslie Tonkonow Artworks + Projects,
New York, NY

Plate 25

MARILYN BRIDGES (American, b. 1948)

*Castillo from the Perpendicular,
Chichen Itza, Yucatán, Mexico*, 1982

Gelatin silver print

20 × 24 in. (50.8 × 61 cm)

Bowdoin College Museum of Art,
Brunswick, Maine; Gift of Mark
Greenberg and Tami Morachnick
(2010.52.8)

Plate 26

MARILYN BRIDGES (American, b. 1948)

Overview, Pathway to Infinity, Nazca, Peru, 1988

Gelatin silver print

24 × 20 in. (61 × 50.8 cm)

Bowdoin College Museum of Art, Brunswick, Maine; Gift of Susan and Neal Yanofsky (2009.18.6)

IN 1948, the Austrian physicist Ronald Richter arrived in Argentina at the invitation of the president, Juan Domingo Perón, to direct the ambitious Huemul Project, the first nuclear fusion program to be officially supported by a national government. Three years later, the scientist pronounced his experiments a success, and Perón announced that the new energy would soon be distributed to homes across Argentina in milk bottle–like containers. In 1952, a regulatory and investigative commission determined that the project was a sham and Richter's adventure came to an end.[1]

The Richter affair raises significant questions: How does one distinguish fantasy from reality in a developing nation that needs to believe in the potential for progress through technological innovation? How closely do the scientific projects of the postwar period resemble inventions from the world of science fiction? This essay explores how such themes are central to the work of many avant-garde Argentine artists during the 1960s, a period

Fig. 1
XUL SOLAR (Argentine, 1887–1963)
Vuel villa (Flying city), 1936
Watercolor on paper
34 × 40 in. (86.4 × 101.6 cm)
Museo Xul Solar, Buenos Aires, Argentina

of rapid industrial growth and relative optimism about the future, as well as political unrest, particularly during the second half of the decade.

Well before the 1960s, fictions, dreams, and fantasies were the foundation for the utopian visions of Argentine artists. Xul Solar conceived a solution to overpopulation through the construction of *Vuel villa* (1936; Flying city, fig. 1). Gyula Kosice's declaration "El hombre no ha de terminar en la tierra" (Man will not end on earth), published in the *Manifesto Madí* (1946), was the point of departure for the project called *La ciudad hidroespacial* (1946–72, and ongoing; Hydrospatial city, see pl. 28), which envisioned a habitat fueled by energy produced from the fission of water molecules.[2] These fantasies were also the basis for some dystopian scenarios, such as that found in Adolfo Bioy Casares's novel *La invención de Morel* (1940; The invention of Morel), the story of an island where a depraved scientist created a virtual reality that captured the souls of a group of human beings for eternity. Héctor Oesterheld's comic strip *El eternauta* (1957; The eternauta), with drawings by Francisco Solano López, provides another example.[3] Written two years after the coup that brought down Perón's government, the comic describes the invasion of Buenos Aires by strange extraterrestrial beings and the subsequent organization of a resistance.

Political events in Argentina divided the 1960s and triggered an ambivalent attitude toward technological advances. In the first part of the decade, Argentina was a progressive, dynamic, and optimistic country, transitioning into a democracy. In 1966, another coup exposed the fragile state of the emerging republic and plunged it into violence and despair.

The 1960s began with the sesquicentennial celebration of Argentine independence. At the international fair Argentina en el Tiempo y en el Mundo (Argentina in time and in the world) organized for the occasion, the United States pavilion dazzled visitors with an exhibition devoted to the civic uses of nuclear energy. The surge in industrialization in Argentina promoted scientific and technological research, which led to the availability of new materials for artistic production. Artists' use of Plexiglas, electrical motors, plastics, and neon lights became common.[4] Argentine kinetic art achieved such renown that a group of practitioners traveled to Paris to dazzle the art center with its works in motion. Their activities led to the formation of Groupe de Recherche d'Art Visuel (GRAV), cofounded by Hugo Demarco, Horacio García-Rossi, and Julio Le Parc.[5]

Kosice managed to give form to an element as difficult to grasp as water, and he published his manifesto *La arquitectura del agua en la escultura* (The architecture of water in sculpture) in 1959. In the 1960s, Kosice showed his "hydrosculptures" in art galleries and public spaces, and the first maquettes of *La ciudad hidroespacial* appeared (fig. 2, see pl. 28). During the same years that the space race nourished humanity's longing to know new worlds, the imaginations of artists attracted by its promises also flew unfettered.

Fig. 2
GYULA KOSICE (Argentine, b. Hungary, 1924)
Constelación (Constellation), 1971
Plexiglas, fluorescent light, wood, and synthetic enamel paint
20½ × 28⅜ × 6¼ in. (52 × 72 × 16 cm)
Collection of the artist

The space/space travel motif pervaded the art of the period, with references to universes, galaxies, constellations, unexplained mysteries, and even the inhabitants of outer space.[6] The Buenos Aires planetarium opened in 1966, and its images of the moon reflected visitors' hopes and expectations about the possibility of man traveling to our remote satellite, well before the first lunar voyage took place.

Raquel Forner was responsible for the most consistent production of Argentine art inspired by the imagery, longings, and mysteries of space exploration (fig. 3, see pls. 14–16). Toward the end of the 1950s, she initiated two series of paintings, *Los espacios* (Spaces) and *Las lunas* (Moons), which touched on these themes. Beginning in 1960, her work began to feature *astroseres* (astrobeings), mutant creatures born from the coupling of humans and possible inhabitants of other worlds. In contrast with her earlier paintings, which displayed the ravages of war, Forner's works from *Los espacios* and *Las lunas* evince a confident, hopeful tone about humanity's future on earth.

Emilio Renart's art shows the impact of space exploration fantasies in a most singular fashion (see pl. 27). In his series *Cosmos* (1960–61), sand is used in paintings on canvas or wood to suggest craters and other features of the lunar surface. Later, in his expansive installations for *Integralismo-Biocosmos* (1962–67; Integralism-biocosmos), he drew from scientific research and science fiction simultaneously to create structures out of diverse media; the works looked as though they were being launched from the walls into the gallery space. The amorphous, ominous-looking forms in these installations remind viewers of monsters from sci-fi films and comic books.

The pop artists who emerged at this time focused on the images of astronauts and space voyages that abounded in the media.[7] Delia Cancela and

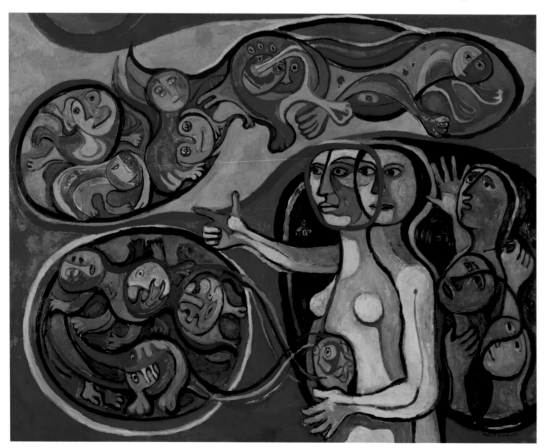

Pablo Mesejean's environment *Love & Life* (1965) included large panels showing pairs of childlike astronauts floating with contagious joy among flowers and clouds (figs. 4, 5). In one section of Marta Minujín's interactive installation *El batacazo* (1965; The long shot), viewers encountered a rubber astronaut that inflated and deflated, standing up and then collapsing in infinite repetition.[8] At the Third American Biennale (1966), a significant art exposition that took place in Córdoba, the most industrialized province in Argentina,

Fig. 3

RAQUEL FORNER (Argentine, 1902–1988)

Gestación del hombre nuevo
(Gestation of the new man), 1980

Oil on canvas

63 × 78¾ in. (160 × 200 cm)

Forner-Bigatti Foundation, Buenos Aires, Argentina

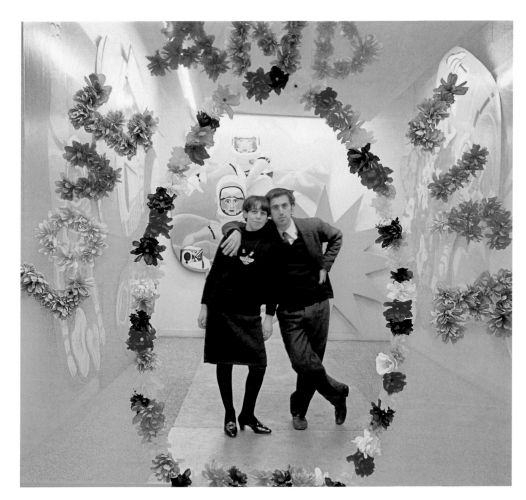

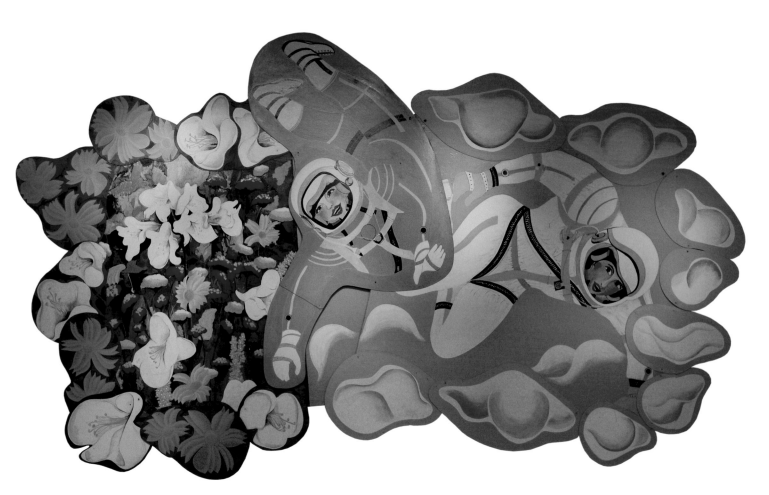

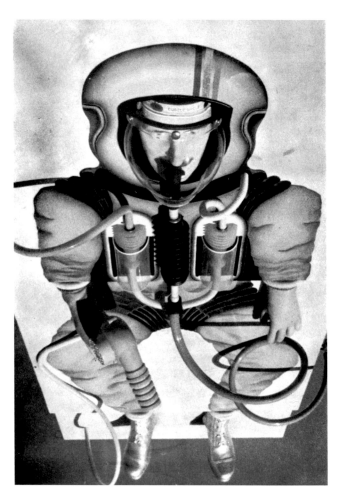

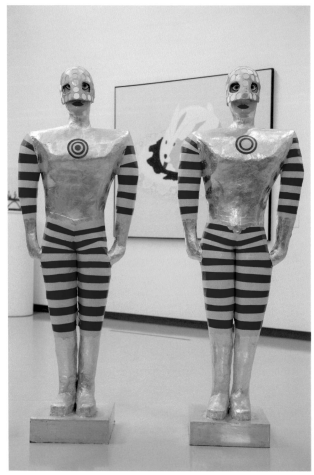

Fig. 6

ERIC RAY KING (Argentine, 1935–2013)

Construcción musical para astronauta evolucionando hacia su cápsula (Musical construction for an astronaut evolving toward his capsule), 1966

Acrylic paint and plastic objects on wood

81⅛ × 33⅞ × 9⅞ in. (208 × 86 × 25 cm)

Fig. 7

JUAN STOPPANI (Argentine, b. 1935)

Soldados del espacio (Space soldiers), 1965/2010

Resin and other materials

78¾ × 19¹¹⁄₁₆ × 15¾ in. (200 × 50 × 40 cm)

Eric Ray King presented an extraordinary picture-object titled *Construcción musical para astronauta evolucionando hacia su cápsula* (1966; Musical construction for an astronaut evolving toward his capsule), which included a space suit, a breathing apparatus, and a hair dryer that blew hot air on the viewer (fig. 6).

Astronauts frequently appeared in these works as emblems of a promising future full of happiness. Leaving aside the difficulties and dangers of space missions, the astronauts represented the artists themselves and the leap forward that they sought to realize in their own media. Space voyages symbolized progress, the avant-garde, the latest thing. Argentine artists followed the space race with admiration, not primarily for the benefits that its achievements signified for humanity but out of the longing to participate in the most current moments of contemporary life. The paraphernalia of space travel—rockets, metallic suits, sophisticated machinery, satellites, extraterrestrial beings, zero-gravity atmospheres—inspired them, and they delighted in the ways it confounded their view of the world.

In his collage *Cita con Greco en Venus* (1960; Date with Greco on Venus), Alberto Greco turned the Obelisk of Buenos Aires, the city's most emblematic monument, into a rocket poised for liftoff (fig. 8). Susana Salgado's *OVNIS* (1965; UFOs), a rendering of unidentified flying objects in papier-mâché, plastic, and electric lights, won the Premio Braque (Braque award), one of the country's most prestigious art prizes. Juan Stoppani used papier-mâché and brightly colored paints to construct *Soldados del espacio* (1965; Space soldiers), an army that resembled comic-book characters (fig. 7). In addition, science-fiction comics and films were

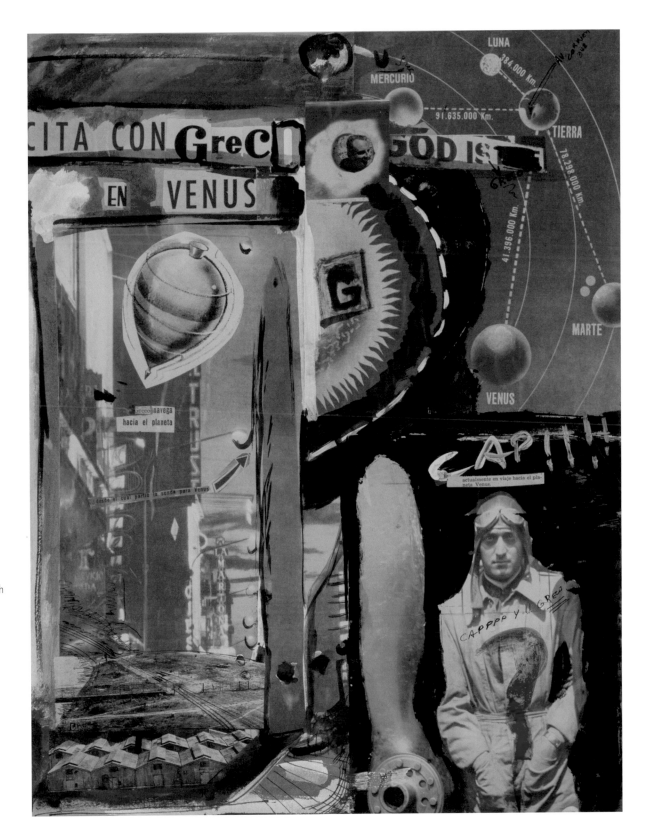

Fig. 8
ALBERTO GRECO (Argentine, 1931–1965)
Cita con Greco en Venus (Date with Greco on Venus), 1960
Mixed media and collage on paper
19¹¹⁄₁₆ × 15¾ in. (50 × 40 cm)

the inspiration for many of the theater and dance spectacles produced at the Instituto Torcuato Di Tella in Buenos Aires, the center for avant-garde Argentine art, including *Marvila la mujer maravilla contra Astra la superpilla del planeta Ultra y su monstruo destructor* (Marvila the marvelous woman vs. Astra the super sneak from Planet Ultra and her destructive monster), a segment of *Danse Bouquet* (1965; Bouquet dance), and *El gabinete* (The machine room), from *¡La fiesta, hoy!* (1966; Party today!), two spectacles choreographed and interpreted by dancers Ana Kamien and Marilú Marini (figs. 9, 10).[9]

The euphoria of a nation amid a cultural and economic boom could be felt in the colorful, playful art of this era, which was contemporaneous with the miniskirt, flower power, the explosion of rock music, sexual liberation, and happenings. Antonio Berni, one of the most notable artists of this period, presented a contrasting view in works from his ongoing *Juanito Laguna* series of the 1960s and 1970s, which juxtapose gleaming space rockets against the misery of a marginalized barrio in Latin America.[10] With *Juanito Laguna y el aeronave* (Juanito Laguna and the spaceship) (fig. 11), the artist emphasized the irrationalism of a society that chose to look toward outer space rather than address its own problems of poverty and social disintegration. This suspicious and critical attitude deepened toward the end of the decade, when a new military incursion limited public and individual freedoms. Censorship intensified and fierce political repression sought to counteract revolutionary thought, the questioning of authority, and the effects of the Paris uprising of 1968 among youth and intellectuals.

Fig. 11
ANTONIO BERNI (Argentine, 1905–1981)
Juanito Laguna y el aeronave (Juanito
Laguna and the spaceship), 1978
Collage and oil on wood panels
82^{11}/$_{16}$ × 63 in. (210 × 160 cm)
Private collection

In the midst of this sociopolitical climate, Hugo Santiago directed *Invasión* (1969; Invasion), a fantasy film with a screenplay by Jorge Luis Borges and Adolfo Bioy Casares. In the film, Buenos Aires has been transformed into the city of Aquilea, axis of an uncertain but imminent invasion and of a resistance that is being organized to stop it. The film was immediately banned and confiscated, and its negatives burned. To express his discontent with this situation, the sci-fi author Eduardo Goligorsky wrote *El vigía* (1967; The lookout), a story about an obscure character who dominates a small community, bringing it to the very brink of submission. The following year, he edited the country's first anthology of science-fiction stories, *Los argentinos en la luna* (1968; Argentines on the moon), a book that demonstrated the genre's relevance and its capacity for political commentary and social criticism (fig. 12).

Fig. 12

Cover of *Los argentinos en la luna* (Argentines on the moon) (Buenos Aires: La Flor, 1968)

In the realm of visual arts, Luis Fernando Benedit produced a series of artificial environments for animals and plants that, like Goligorsky's *El vigía*, conveyed notions of surveillance and control (figs. 13–15). In his *Hábitats* (Habitats) and *Laberintos* (Labyrinths), which were begun in 1965 but were executed primarily during the early 1970s, Benedit built transparent Plexiglas containers in which he placed animals or plants that were given minimal resources for their survival (see pls. 33–35). The viewer became a kind of Big Brother who clinically examined the behavior of these isolated subjects. Benedit's projects, based on the design of laboratory experiments and on the notion of systems art, followed the conceptual and technological research that prompted Jorge Glusberg to organize the exhibition *Arte y cibernética* (1969; Art and cybernetics) at the Centro de Arte y Comunicación (CAYC).[11] By making allusions to systems of control and observation, Benedit's art and this exhibition served as allegories for this dark period in Argentine history at the end of the 1960s and, to some degree, presaged a period of even greater violence and repression in the years to come.

Translated from the Spanish by Janice Jaffee.

Fig. 13

LUIS FERNANDO BENEDIT
(Argentine, 1937–2011)

Biotron, 1970

Installation view at 35th Venice Biennale

Plexiglas, aluminum, PVC, wood, 50 electric lamps, electric generator, 25 artificial flowers, and 4,000 living bees

118⅛ × 196⅞ × 78¾ in. (300 × 500 × 200 cm)

Fig. 14

LUIS FERNANDO BENEDIT
(Argentine, 1937–2011)

Hábitat para caracoles (Habitat for snails), 1970

Polyethylene, wood, Plexiglas, sand, vegetables, and living snails

31½ × 15¾ × 15¾ in. (80 × 40 × 40 cm)

Fig. 15

Visitors to the 35th Venice Biennale observing Luis Fernando Benedit's *Biotron*, 1970

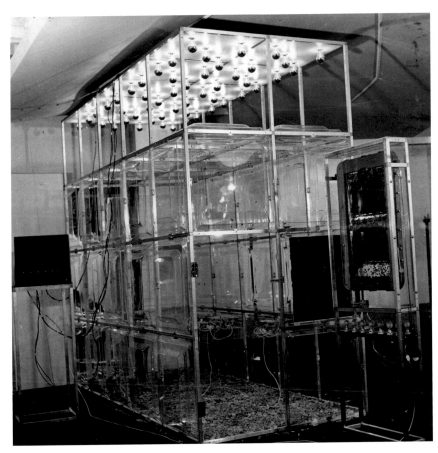

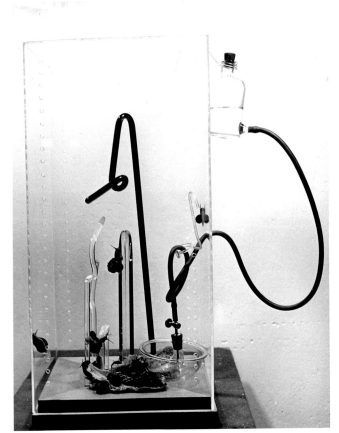

NOTES

The title of this essay is inspired by the Spanish expression *estar en la luna*, literally, to be on the moon, to be lost or disoriented.

1 This story was the basis for the documentary opera *Richter* (2003) by Esteban Buch, with music by Mario Lorenzo.

2 Kosice was a cofounder of the Madí group of concrete artists who revolutionized the Argentine visual arts scene in the 1940s.

3 Oesterheld was disappeared during the military dictatorship in Argentina (1976–83).

4 Plastics would also be widely used due to the support of the Cámara Argentina del Plástico (Association for Argentine Plastics), which promoted artistic experimentation with its polymers.

5 GRAV was founded by Le Parc, García-Rossi, Demarco, François Molleret, Francisco Sobrino, Joël Stein, and Yvaral (Jean-Pierre Vasarely) in 1960. The group experimented with optic (op), light, and kinetic works that encouraged the participation of the viewer.

6 See, for example, Gregorio Vardánega, *Universo electrónico* (1958; Electronic universe); Fernando López Anaya, *Galaxia* (1962; Galaxy); Nicolás Espósito, *Constelación* (1965; Constellation); Ana Josefa Bettini, *OVNI—Enigma especial* (1965; UFOs—Spatial enigma); and Enrique Romano, *Monstruo del espacio* (1961; Space monster).

7 Pop art began to develop in Argentina in 1962, uniting around the Instituto Torcuato Di Tella de Buenos Aires. The avant-garde institution was financed by a national electrical appliances firm.

8 This installation was displayed at the Galería Bianchini in New York the year after it was created.

9 Additional performances at the Di Tella Institute include Alfredo Rodríguez Arias's *Futura* (1968; Future) and Oscar Aráiz's *Crash*, 1967.

10 Antonio Berni achieved international renown when he won the Grand Prize for Engraving at the 1962 Venice Biennale.

11 This show was inspired by the milestone exhibition *Cybernetic Serendipity*, which opened in 1968 at the Institute of Contemporary Arts in London.

Plate 27

EMILIO RENART (Argentine, 1925–1991)

Drawing No. 13, 1965

Ink on paper

44 × 30 in. (111.8 × 76.2 cm)

OAS | Art Museum of the Americas
Collection

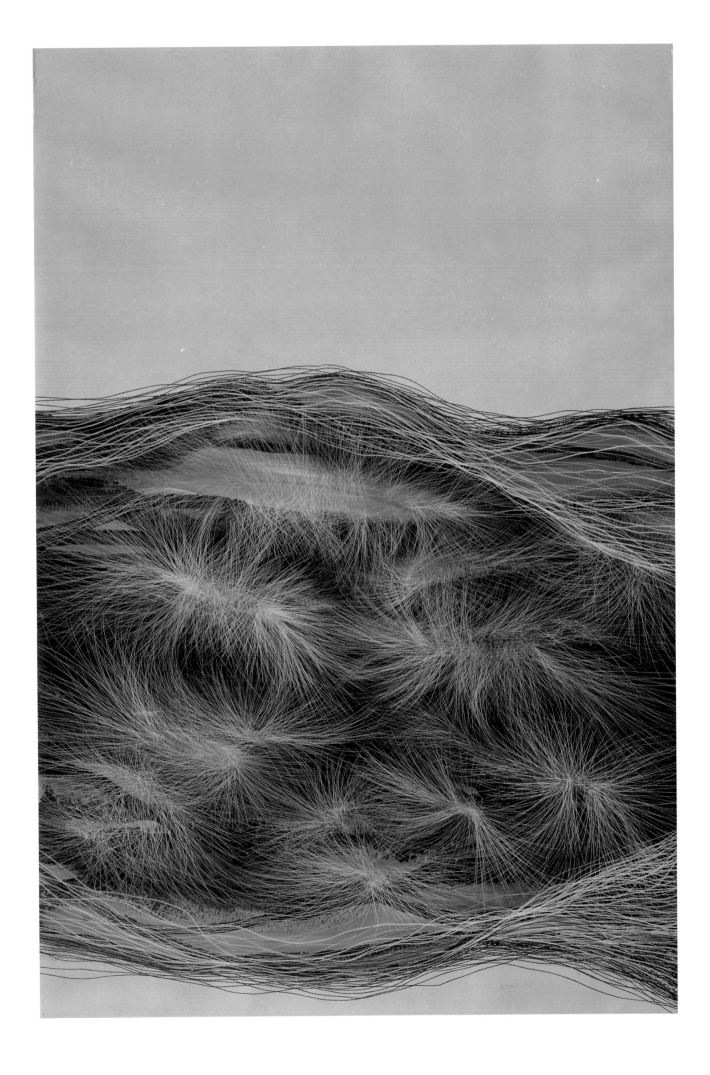

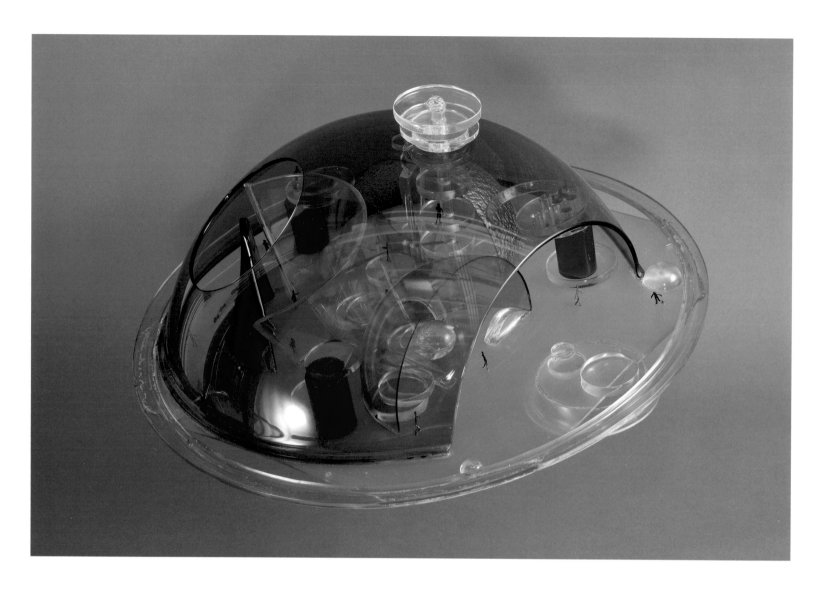

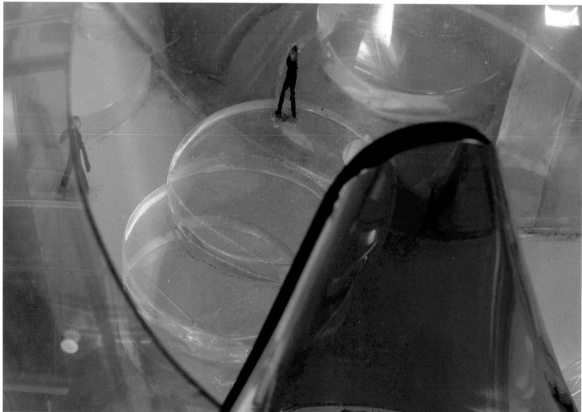

Plate 28

GYULA KOSICE (Argentine, b. in Hungary, 1924)

Maqueta D—Hábitat. La ciudad hidroespacial (Model D—Habitat. Hydrospatial city), 1950

Plexiglas and metal

8³⁄₁₆ × 8³⁄₁₆ × 4⅝ in. (20.8 × 20.8 × 11.8 cm)

Blanton Museum of Art, The University of Texas at Austin, Gift of the artist, 2007 (2007.17)

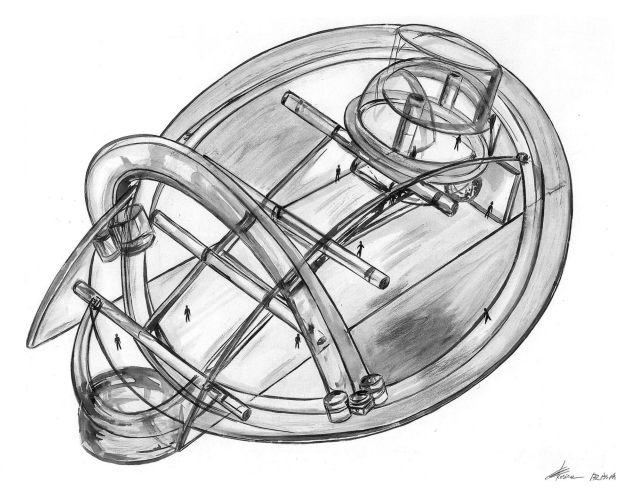

Plate 29

GYULA KOSICE (Argentine, b. in Hungary, 1924)

Untitled, 1972

Pen and brush with wash over pencil on paper

18⅞ × 24¹³⁄₁₆ in. (47.9 × 48 cm)

Blanton Museum of Art, The University of Texas at Austin; Gift of Barbara Duncan, 1974 (G1974.18.5)

Plate 30

GYULA KOSICE (Argentine, b. in Hungary, 1924)

Untitled, 1972

Pen and brush with wash over pencil on paper

19⅞ × 25¼ in. (50.5 × 64.1 cm)

Blanton Museum of Art, The University of Texas at Austin; Gift of Barbara Duncan, 1974 (G1974.18.6)

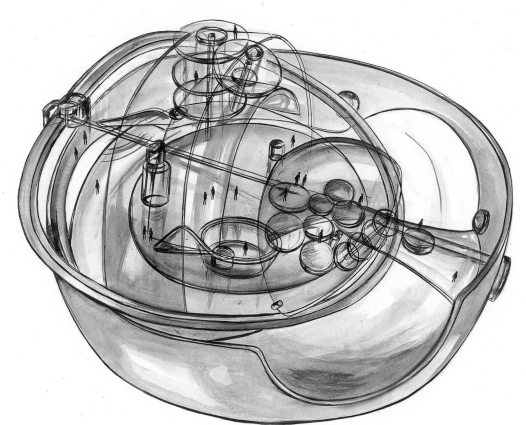

Plate 31

HORACIO ZABALA (Argentine, b. 1943)

Tres anteproyectos, serie I-B, (Three
preliminary plans, series I-B), 1974

Pencil on paper

13¾ × 43 in. (34.9 × 109.2 cm)

Henrique Faria Fine Art, New York
and Buenos Aires

ANTEPROYECTO DE CARCEL SUBTERRANEA

ANTEPROYECTO DE CARCEL SOBRE COLUMNA

PLANTA ESC. 1:50

ELEVACION ESC. 1:50

CORTE ESC. 1:50

-3,80

+2,00

+3,20

CORTE

ELEVACION

PLANTA ESC. 1:50

TRES ANTEPROYECTOS — SERIE I-B

TABATA 74

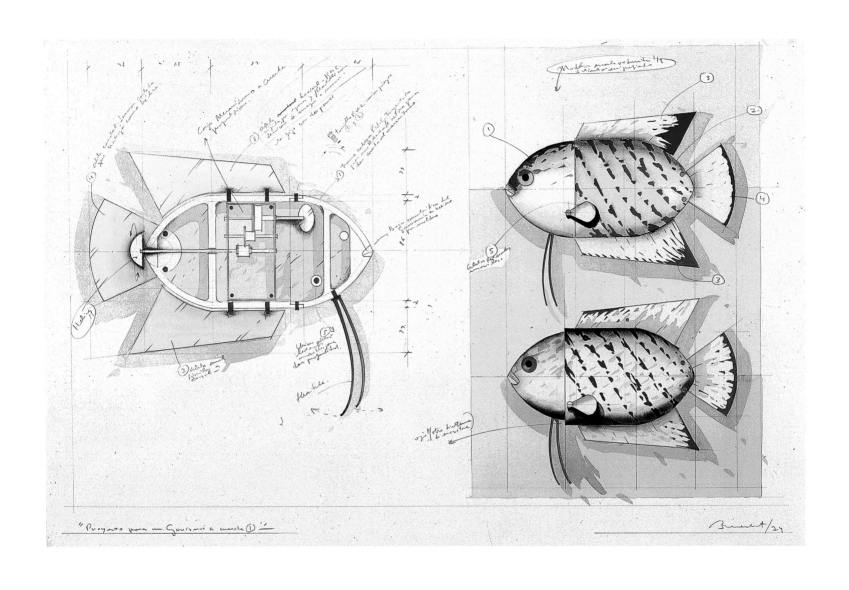

Plate 32

Luis Fernando Benedit (Argentine,
1937–2011)

Proyecto para un guramí a cuerda 1
(Project for a Clockwork Gurami 1), 1974

Pencil and watercolor on paper

17⅝ × 27⅜ in. (44.8 × 69.5 cm)

Blanton Museum of Art, The University of
Texas at Austin; Gift of Barbara Duncan
(1994 1994.91)

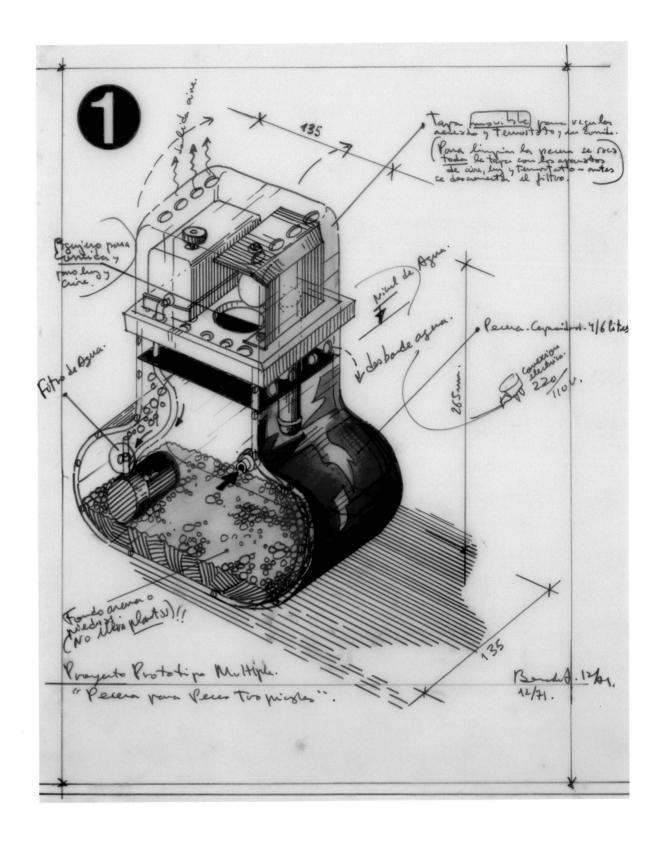

Plate 33

LUIS FERNANDO BENEDIT (Argentine,
1937–2011)

*Proyecto prototipo múltiple "Pecera para
peces tropicales"* (Prototype multiple
project "Fishbowl for tropical fish"), 1971

Ink on mylar

15½ × 12¾ in. (39.4 × 32.4 cm)

Henrique Faria Fine Art, New York
and Buenos Aires

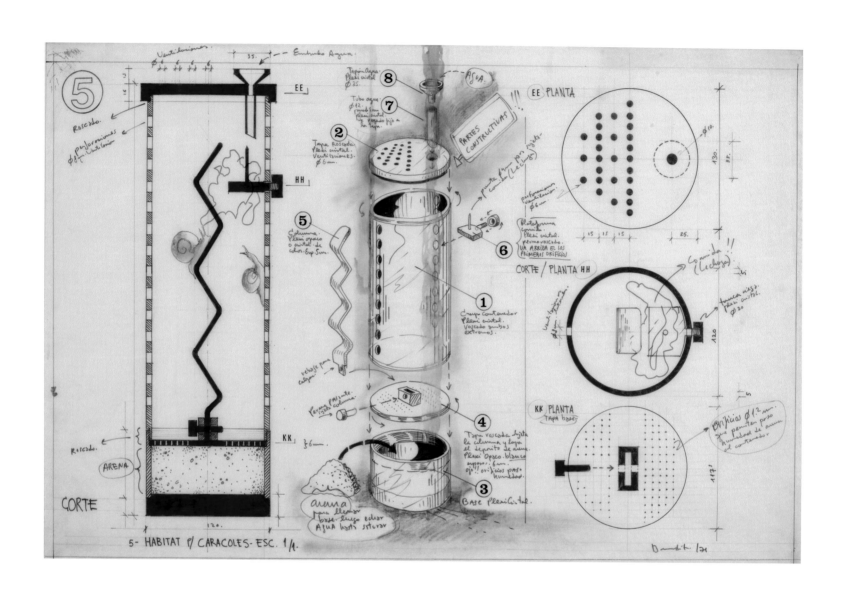

Plate 34

Luis Fernando Benedit (Argentine, 1937–2011)

Hábitat para caracoles (Habitat for snails), 1971

Ink and adhesive letters on mylar

18¾ × 28½ in. (47.6 × 72.4 cm)

Henrique Faria Fine Art, New York and Buenos Aires

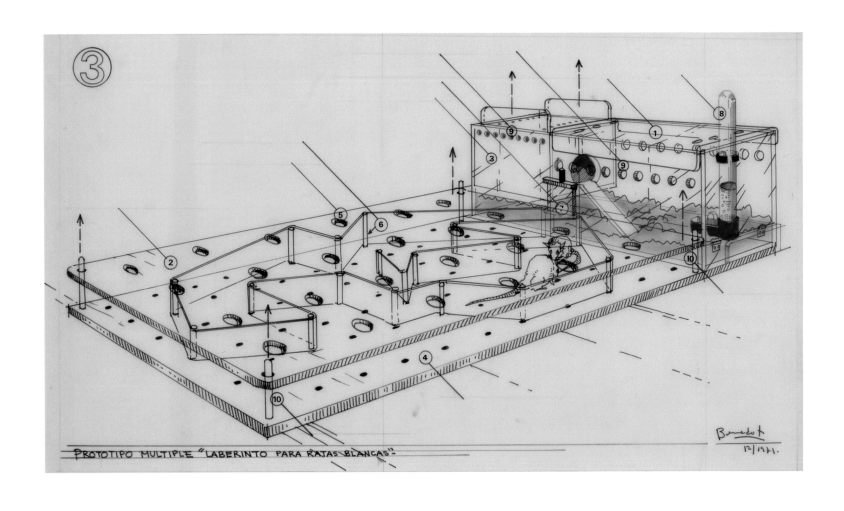

PROTOTIPO MULTIPLE "LABERINTO PARA RATAS BLANCAS"

Plate 35

LUIS FERNANDO BENEDIT (Argentine, 1937–2011)

Prototipo múltiple "Laberinto para ratas blancas" (Prototype multiple "Labyrinth for white rats"), 1971

Ink and adhesive letters on mylar

15¾ × 27⅝ in. (40 × 70.2 cm)

Henrique Faria Fine Art, New York and Buenos Aires

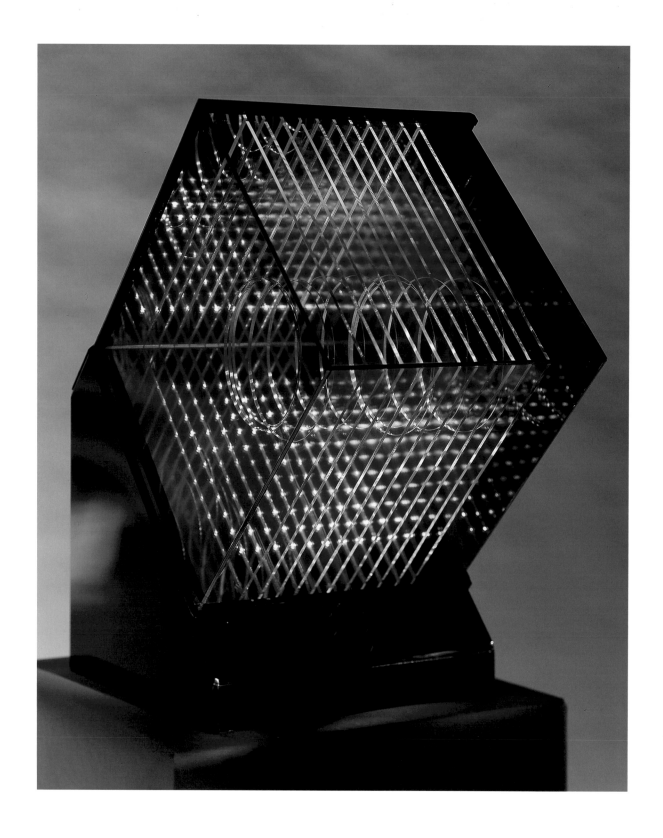

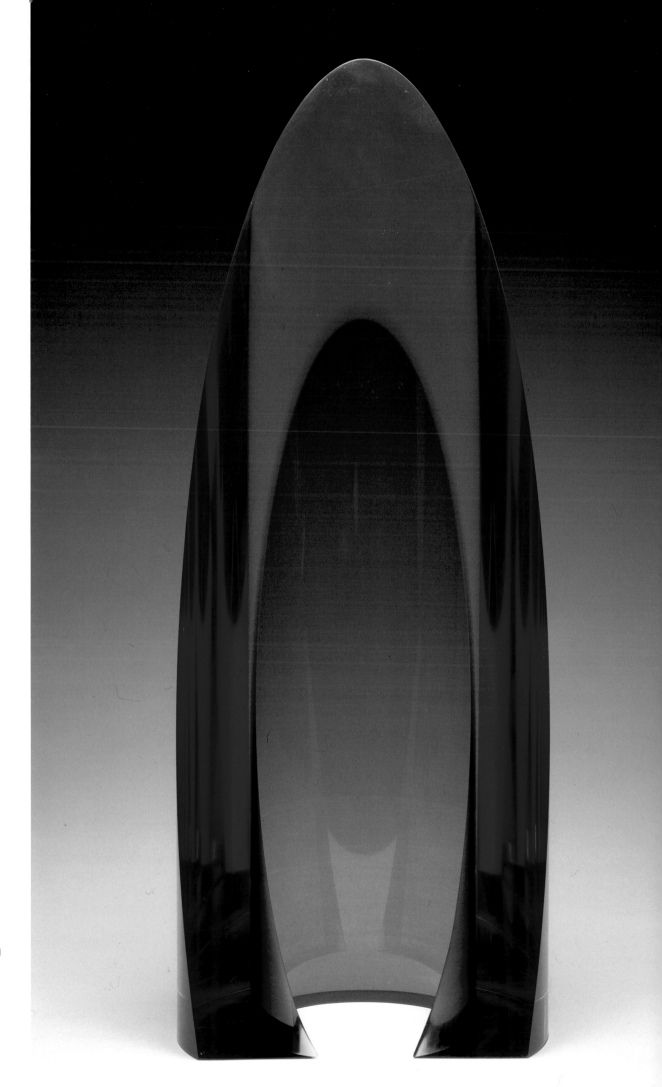

Plate 37

FREDERICK JOHN EVERSLEY (American, b. 1941)

Untitled, 1970

Cast polyester resin

19 × 7½ × 5⅞ in. (48.3 × 19.1 × 14.9 cm)

Smith College Museum of Art, Northampton, Massachusetts; Gift of Barbara P. Jakobson (Barbara Petchesky, class of 1954) (1983.38)

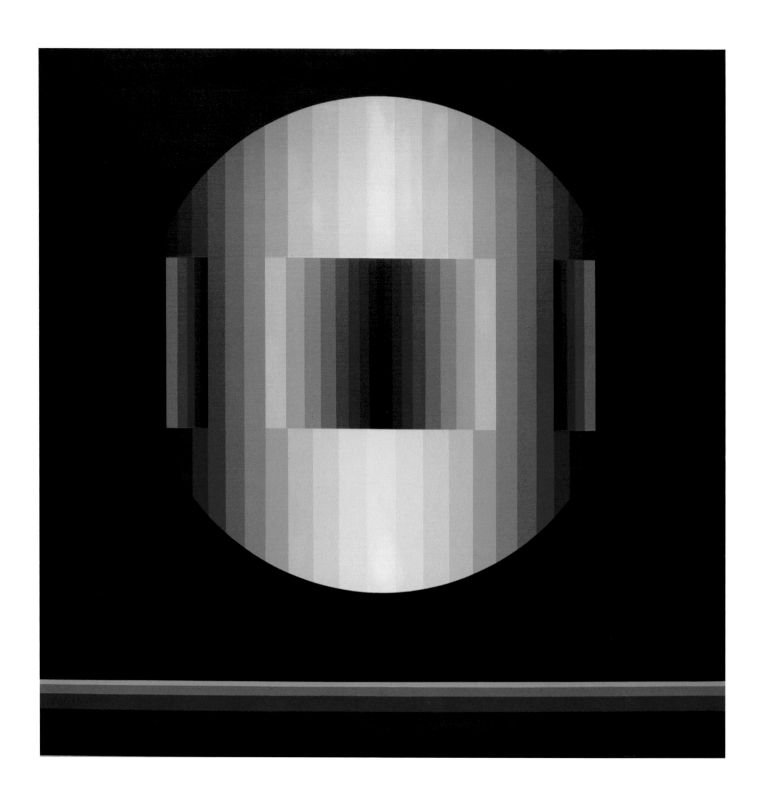

Plate 38
ENRIQUE CAREAGA (Paraguayan, 1944–2014)
Sphere Spatio-Temporelle FSW 7561,
1975
Acrylic on canvas
31½ × 31½ in. (80 × 80 cm)
OAS | Art Museum of the Americas
Collection

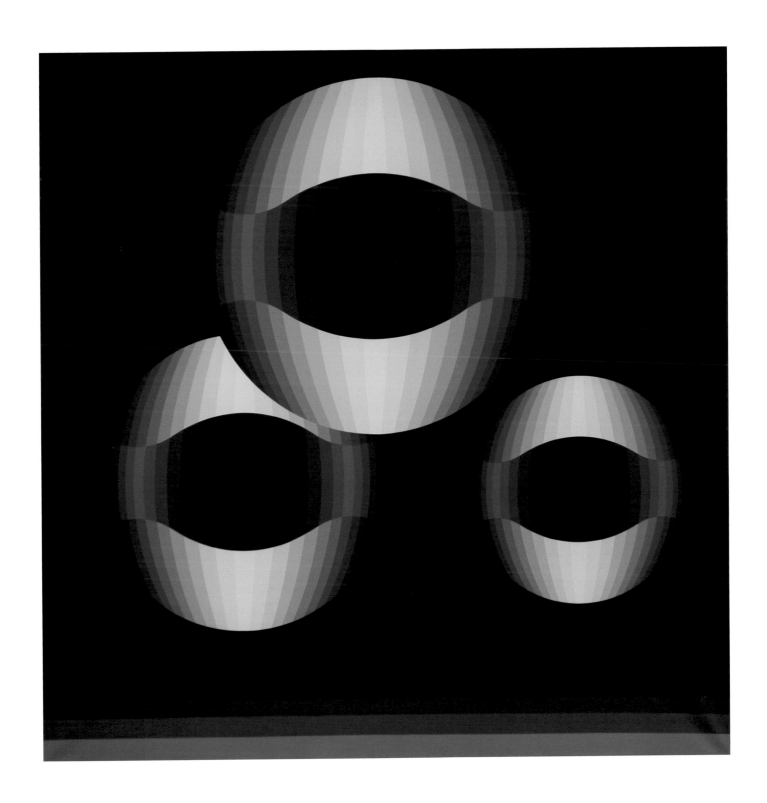

Plate 39

ENRIQUE CAREAGA (Paraguayan, 1944–2014)

Sphere Spatio-Temporelle BS 7523,
1975

Acrylic on canvas

47½ × 47½ in. (120.7 × 120.7 cm)

OAS | Art Museum of the Americas
Collection

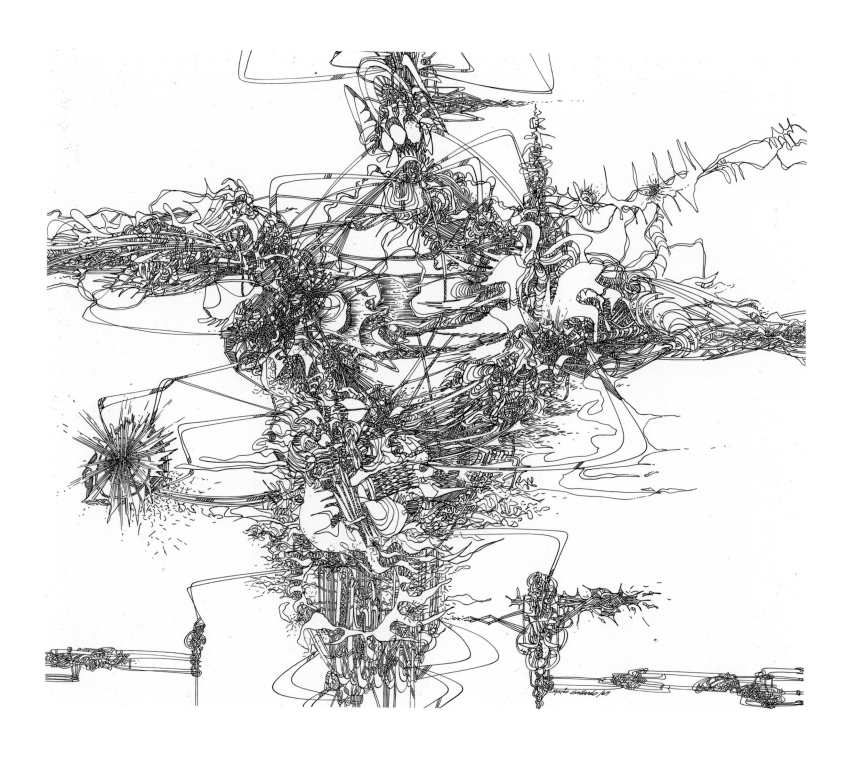

Plate 40

MARIO GALLARDO (ODRALLAG) (Mexican,
b. in Cuba, 1937)

*Significación Macrocosmismo:
"Desplazamiento"* (Macrocosmic
meaning: "*Displacement*"), 1969

Ink on cardboard

20 1/16 × 24 13/16 in. (51 × 63 cm)

Collection of the artist

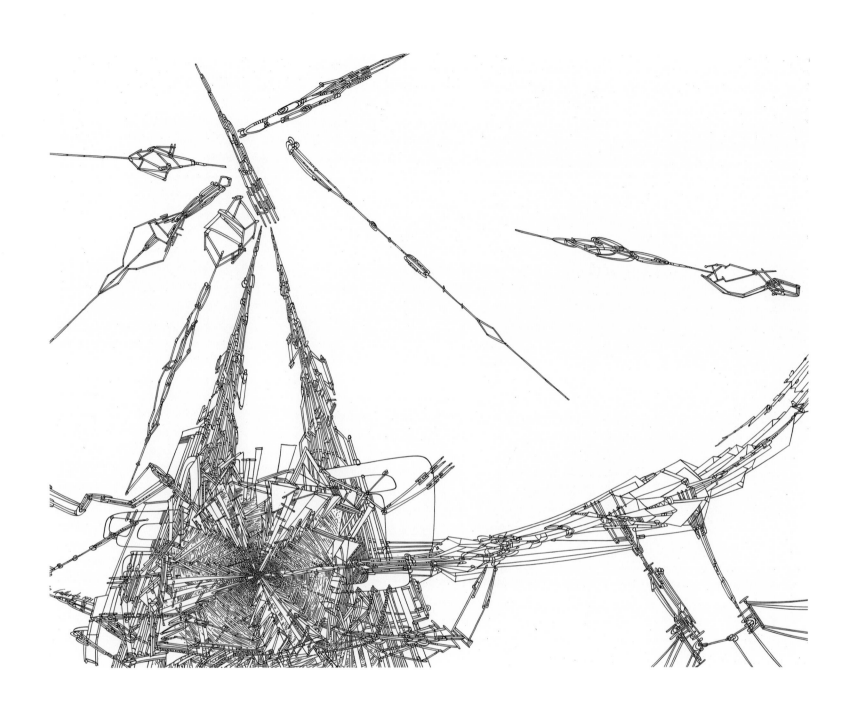

Plate 41

MARIO GALLARDO (ODRALLAG) (Mexican,
b. in Cuba, 1937)

*Significación Macrocosmismo:
"Torre Automatizada"* (Macrocosmic
meaning: "*Automated Tower*"), 1971

Ink on cardboard

18½ × 24⁷⁄₁₆ in. (47 × 62.1 cm)

Collection of the artist

THE OTHER SIDE
OF ROBERT SMITHSON'S
MIRROR-TRAVEL

RORY O'DEA

SCIENCE FICTION

I N the summer of 1969, Robert Smithson journeyed to the Yucatán Peninsula to produce a series of sculptural "mirror displacements," photographs of which were later published in his seminal essay "Incidents of Mirror-Travel in the Yucatan" (see pl. 46).[2] The final work is comprised of the fleeting mirror installations and the photojournalistic essay that documents them. Smithson did not categorically distinguish his visual art from his writing but instead drew the two modes into a dialectical relationship that forces the viewer-reader to imaginatively oscillate between the material world and its representation. Smithson conceived of this excursion in response to John Lloyd Stephens's *Incidents of Travel in Yucatán*, a nineteenth-century travelogue chronicling his archaeological expeditions through Mexico and Guatemala.[3] Yet, Smithson's work stands as a critical counter to the imperialistic and scientific ethos embodied in Stephens's text. Rather than seeking to methodically survey and objectively document the Yucatán region, Smithson's "anti-expedition" sought to "travel at random" into the unknown, searching only for the "true fiction [that] eradicates the false reality."[4]

Smithson's essay explores the myriad ways that language, representation, and rational systems of knowledge construct our perception of the world and consequently determine our experience of it. And it is precisely this probing epistemological inquiry about the very nature of reality that aligns his practice so powerfully with the genre of science fiction. Yoking *science* and *fiction* to create a new term, sci-fi distinguishes itself from other art forms through its complex interplay of seemingly antithetical systems of knowledge and representation. The genre is built upon the tension that arises from our desire to objectively know and subjectively create the world, and it thus blurs the boundary between what we understand to be fact and what we presume is fiction.

The correspondences between Smithson's "Incidents of Mirror-Travel in the Yucatan" and the science-fiction genre are best understood in terms of their shared apocalyptic imagination, a concept whose particular meaning comes into focus through the lens of British sci-fi author J. G. Ballard's disaster novels. Rather than a spectacular celebration of destruction, which is certainly a hallmark of much cinematic sci-fi, the sense of apocalypse at work here takes the form of estrangement and revelation. In this sense, Smithson and Ballard's mutual fascination with entropy takes on a striking new significance. Rather than mere decay or chaos, *entropy*—originating from the Greek *trope*, meaning to change or, literally, to turn—signals the transformation from one state to another. Through descriptions and representations of landscapes that exceed rational understanding, Smithson and Ballard induce seismic shifts in perception and consciousness, and the empirical reality of the reader is metaphorically destroyed by the fictional otherness of the text.

Smithson was a voracious reader of science fiction, and his collected writings and personal library map his wanderings across the sci-fi universe (fig. 1). He often referenced science-fiction texts and films in his writing, and his taste for the genre spanned its historical breadth and cultural hierarchies. The works of iconic figures Edgar Allan Poe and H. G. Wells

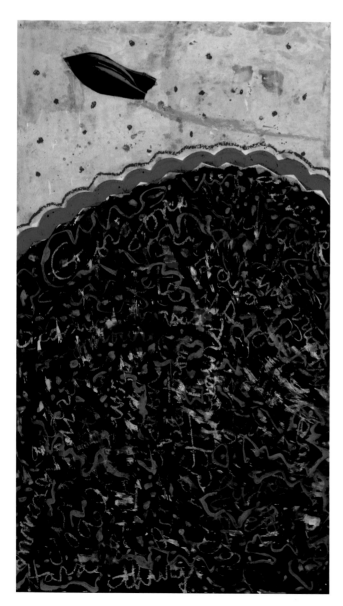

Fig. 1

ROBERT SMITHSON (American, 1938–1973)

Conch Shell, Space Ship, and Word Land Mass, c. 1961–63

Collage, gouache, and crayon

24 × 14 in. (61 × 35.6 cm)

Private collection

© Estate of Robert Smithson / Licensed by VAGA, New York, NY

sat on Smithson's bookshelves alongside those of contemporary innovators Ballard and Brian Aldiss. And the artist was as likely to be found at a Forty-Second Street grind house showing of *Creation of the Humanoids* (1962) as he was to be at a downtown art house watching Chris Marker's *La Jetée* (1962).

Smithson's marked interest in science fiction has been acknowledged in passing by scholars, yet it has not been developed into a more serious and nuanced consideration (see pl. 42).[5] Though the reasons underlying this neglect are complex, they can be understood in the context of the broader academic dismissal of sci-fi as subliterary escapist kitsch. Taking this characterization as a given, it is all too easy to cast aside Smithson's predilection for sci-fi as an idiosyncrasy that played no generative role within his art and its rigorous critique of Clement Greenberg's modernist aesthetics.[6]

The irony of this reductive view is that science fiction is intimately connected to modernism, and both share a conceptual logic that is shaped by the scientific worldview of the Enlightenment and its instrumentalization in the ensuing Industrial Revolution. As the sci-fi author and scholar Joanna Russ observes, science fiction "draws its beliefs, its material, its great organizing metaphors, its very attitudes, from a culture that could not exist before the industrial revolution, before science became an autonomous activity and a way of looking at the world."[7] The same could be said of modernism. In "Avant-Garde and Kitsch" (1939), Greenberg traces the origins of modernism to the Enlightenment, arguing that "the birth of the avant-garde coincided chronologically—and geographically too—with the first bold development of scientific revolutionary thought in Europe."[8] Science fiction was more than a mere lowbrow affront to Greenberg's highbrow tastes; sci-fi offered Smithson a main line into modernism's unconscious desires and secret logics.

Despite Greenberg's claim for the autonomy of modernist aesthetics, his ideas about art are highly reflective of the broader cultural tendencies of the emergent technocracy in the postwar United States. Tellingly, Greenberg titled his first book review "Aesthetics as Science"(1941).[9] And throughout his writings, he argued that the positivist roots of his formalism could be traced to the scientific objectivity of impressionism, which "rested on a sufficient acceptance of the world as it must be, and it delighted in the world's very disenchantment, seeing it as evidence of man's triumph over it."[10] In 1960s America, the scientific worldview and its program of disenchantment reached its apotheosis, exemplified by the cold rationalism of the space race. Echoing John Keats's lament that science should desire to "unweave a rainbow," Charles "Pete" Conrad, Jr., commander of Apollo 12, somberly confessed that "now the moon is nothing but facts to me."[11] The moon and art alike, it seemed, were losing their magic.

But for Smithson, the privileged position of the scientific worldview could no longer be maintained. In his 1968 essay "A Museum of Language in the Vicinity of Art," the artist insists that "the philosophism of 'reality' ended some time after the bombs were dropped on Hiroshima and Nagasaki and the ovens cooled down."[12] The "reality" that had ended in Smithson's mind was that of a stable and rationally ordered world. This skepticism was a hallmark of much contemporary science fiction as well. In the prescient work of such writers as Ballard, Aldiss, and Philip K. Dick, Smithson found a kindred response to the fallout of World War II, which had revealed the irrational side of modernism's utopian project. For his part, Ballard turned

away from science fiction's archetypal narrative of space exploration and called for the genre to explore "inner space" instead:

> I'd like to see more psycho-literary ideas, more meta-biological and meta-chemical concepts, private time systems, synthetic psychologies and space-times, more of the somber half-worlds one glimpses in the paintings of schizophrenics, all in all a complete speculative poetry and fantasy of science.[13]

Perceiving that the reality of the 1960s had caught up with science fiction's visions of the future, Ballard and his fellow writers turned radically inward, deconstructing both the ideologies of science and the structure of the material world. For them, fiction became a revelatory means of producing alternate realities and modes of consciousness.

As we shall examine below, Smithson's Yucatán project was fundamentally concerned with deconstructing the version of objective reality presented by the positivist worldview. In this way, the work can be understood as a brilliant culmination of embryonic ideas and critical concerns explored in his earlier art and writing. A revealing example is *Quick Millions* (1965), a hybrid art object made of corrugated plastic that can be described as equal parts painting, sculpture, and futuristic relic. In a brief essay describing the work, Smithson wrote, "*Quick Millions* comes out of a world of remote possibilities, held together by incomprehensible motives. . . . sealed, impenetrable, unrevealing—forever hidden. I like plastic as a medium because it can be both real and/or unreal."[14] Refuting the objectivity of minimalism's unitary gestalts and "specific objects," *Quick Millions* presents a disorienting, alien form, and Smithson's own interpretation questions both its meaning as a work of art and its existence as an object.

Estrangement and dislocation are also the guiding principles of Smithson's "Incidents of Mirror-Travel in the Yucatan," which takes the science-fictional trope of a voyage into the unknown as its conceptual starting point. Smithson's essay combines disinterested documentary photographs and ruminative, fantastical prose to record his journey through the Yucatán Peninsula. The various stages of his travels were marked at nine different sites by the creation of "mirror displacements," which consisted of twelve mirrors installed in loose grids (see pl. 46). Smithson photographed and then disassembled each installation. These ephemeral sculptures functioned as anti-monuments, the fleeting reflections on the mirrors' surfaces portended the sculptures' very disappearance, and their only remains exist as ghostly traces in Smithson's photographs.

For Smithson, the camera was emblematic of the objectifying gaze of modernism: a technological extension of the rational mind capable of transforming raw nature into a unified picture. This technical alchemy, which originated with linear perspective and culminated with photography, changed the world into image, and it represents one of the paradigmatic shifts of modernity. Rather than a direct and immersive experience, this perspective keeps the viewer at a distance, insisting that we interpret reality a priori through the anthropomorphizing patterns of language and representation. The multiplicity of forms that make up the world is reduced to rigid systems of classifications and facts. But in the face of the mirror displacements, the logic that photography provides—which Smithson described as the "conceptual fallacy"—breaks down.[15]

In Smithson's photographs, the mirrors' uniform geometry and clear boundaries stand in stark contrast to the formless materiality of the landscape surrounding them. Rather than picturing the landscape within their framing edge, the surfaces of the mirrors form shimmering holes within the ground upon which they sit. In this way, the mirrors disrupt rather than reflect the landscape, fracturing our perception and forcing us to toggle between nature and its representation. But the two cannot resolve into a single image. As Smithson observes, "The mirror surfaces being disconnected from each other 'destructuralized' any literal logic. Up and down parallels were dislocated into twelve centers of gravity."[16] Each mirror becomes a hole in the landscape and a world unto itself, its shimmering surface evoking a visionary world beyond the reach of the camera.

The artist is suggesting not only that photography is an inadequate method of representation but also that the Yucatán landscape and his perceptions of it are fundamentally *unrepresentable*. Smithson saw the Yucatán as "a kind of alien world, a world that couldn't really be comprehended on any rational level."[17] Far removed from the cultural center of New York City, Smithson feels disoriented by the natural otherness of the Yucatán landscape; the formal logic of the city—alluded to by the grid structure of the mirror displacements—is replaced by the entropic formlessness of the jungle.[18] Throughout the essay, Smithson vividly describes the feeling of crossing over into a hallucinatory consciousness, "a discontinuous state of being, a world of quiet delirium."[19] This new consciousness—which is best understood in terms of entropy and the sublime—arises from what Smithson describes as a "catastrophe of mind and matter," whereby the rational boundaries separating subject and world are dissolved.[20]

Smithson expresses the crux of this perceptual shift through the disappearance of objects. Though this disappearance literally occurs as a result of his dismantling of the mirror sculptures, the artist also offers a more visionary account of his experience, whereby he witnesses the defining boundaries of the world come undone in the Yucatán. The essay begins with a fantastical description of the horizon line, powerfully subverting its function as the organizing center of Western perspectival painting: "Quite apathetically it [the horizon] rests on the ground devouring everything that looks like something. . . . In this line where sky meets earth, objects cease to exist."[21] Later, he insists that "'objects' are 'sham space,' the excrement of thought and language. . . . Objects are phantoms of the mind, as false as angels."[22]

Through his art, Smithson aimed to do away with the rigidity of subject-object relations, which he felt to be the defining structure of Greenberg's positivist aesthetics as well as the specific objects and gestalt of minimalist sculpture. Clearly, the artist's abiding obsession with entropic decay in nature reflects his desire to rid his art of its object-ness, and his use of mirrors should be understood as a means to the same end. For Smithson, the mirroring of objects intimated a higher order of reality, revealing an infinitely repeating macrocosmic pattern. The revelation of this pattern allows one to transcend the rational boundaries of self and world, opening a mode of irrational perception into what Smithson described as a "nonworld." Smithson's nonworld is analogous to Kasimir Malevich's concept of the "non-objective world," which is expressed in the abstract forms of Malevich's paintings, and which Smithson referred to time and again throughout his writings.[23]

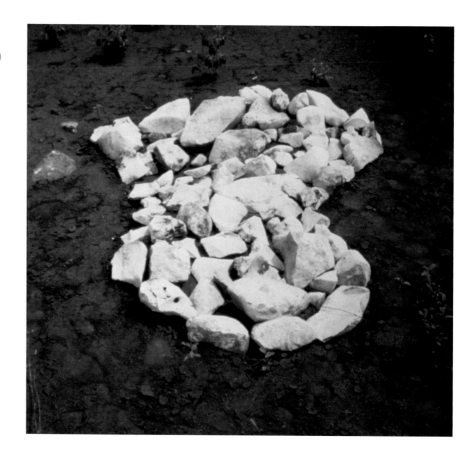

The particular nature and implications of the visionary consciousness that Smithson describes in the Yucatán essay finds another profound analogue in Ballard's 1962 sci-fi novel *The Drowned World*. The novel is set in a postapocalyptic future, when increased global temperatures and rising sea levels have submerged much of the earth and catalyzed a proliferation of jungle growth. The narrative follows the protagonist, Kerans, a member of a scientific team attempting to remap the world's landmasses and thus restore cartographic order to the formless chaos. Over time, Kerans begins to resist the team's efforts, as he believes the environmental changes portend revolutionary transformations of the inner psyche: "A more important task than mapping the harbours and lagoons of the external landscape was to chart the ghostly deltas and luminous beaches of the submerged neuronic continents . . . where old categories of thought were merely an encumbrance."[24] In the Yucatán essay, Smithson describes similarly abandoning the use of maps, which, like photographs, are a means of rationally ordering experience a priori. Communing with the ancient Aztec god, Tezcatlipoca, Smithson is told, "'All those guidebooks are of no use. . . . You must travel at random, like the first Mayans; you risk getting lost in the thickets, but that is the only way to make art.'"[25]

The entropic changes in the external landscape of *The Drowned World* awaken Kerans to the collective unconscious, which manifests in sublime dreams of an unending and all-consuming Triassic jungle that is reminiscent of Max Ernst's seething surrealist landscapes. Ballard describes the profound psychic stirrings of the dreams in terms of a primordial return, whereby "we are now being plunged back into the archaeopsychic past. . . . Each one of us is as old as the biological kingdom, and our bloodstreams are tributaries of the great sea of its total memory."[26] This shift from historic to prehistoric time is enacted in Smithson's "Incidents of Mirror-Travel in

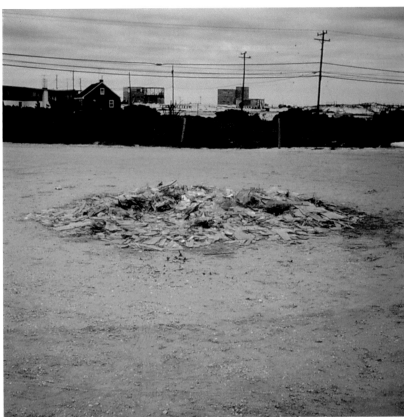

the Yucatan" as well as through his sculptural reconstruction of the ancient continent of Gondwanaland, a work also made while traveling: "It was an 'earth-map' made of white limestone. Reconstructing a landmass that existed 350 to 305 million years ago on a terrain once controlled by sundry Mayan gods caused a collision in time that left one with a sense of the timeless" (see fig. 2, pl. 43)[27] The new consciousness evoked by Smithson and Ballard represents the transformation of historical time into the greater reality of eternity, time without end. At the conclusion of Ballard's novel, the rational boundaries separating Kerans from the watery depths and consuming jungle have vanished, and he gives himself over to an oceanic state: "He felt the barriers which divided his own cells from the surrounding medium dissolving, and he swam forward, spreading out across the black thudding water."[28]

Both Smithson and Ballard have been criticized for the relentless pessimism and morbidity of their art. Yet, if there is a fixation on death, it is the death of a particular way of life, as represented by Western modernity. Viewed from this perspective, Smithson and Ballard's entropic dissolution of the world does not reflect a state of cynical resignation but, rather, the apocalyptic revelation of a new world in place of the old. In this way, the eschatology of entropic dissolution envisioned by Smithson and Ballard points toward the shared visionary quality of their work and allows us to understand them in the larger context of the Dionysian counterculture that emerged in the 1960s. In the work of Smithson and Ballard, the objective picture of the world gives way to a quasi-mystical, science-fictional utopia—a literal "nowhere"—that is revealed rather than created (figs. 3, 4). For Smithson, this other world, which could be found on the other side of his mirrors in the Yucatán, was the true fiction that eradicates the false reality.

Fig. 3

ROBERT SMITHSON (American, 1938–1973)

Map of Broken Clear Glass (Atlantis), 1969

Collage, photostat, map, and graphite on paper

16¾ × 14 in. (42.6 × 35.6 cm)

Dia Art Foundation; Gift of Nancy Holt

© Estate of Robert Smithson / Licensed by VAGA, New York, NY

Fig. 4

ROBERT SMITHSON (American, 1938–1973)

Hypothetical Continent (Map of Broken Glass, Atlantis), Loveladies, NJ, 1969

One of four original 126-format chromogenic-development transparencies

Collection of the Estate of Robert Smithson, James Cohan Gallery, New York

© Estate of Robert Smithson / Licensed by VAGA, New York, NY

NOTES

1 Jorge Luis Borges, "Avatars of the Tortoise," in *Labyrinths: Selected Stories and Other Writings*, ed. Donald A. Yates and James E. Irby (New York: New Directions, 1964), 208.

2 Robert Smithson, "Incidents of Mirror-Travel in the Yucatan," in *Robert Smithson: The Collected Writings*, ed. Jack Flam (Berkeley: University of California Press, 1996), 119–33. The essay was originally published in the September 1969 issue of *Artforum*.

3 For an exceptional analysis of Smithson's Yucatán essay in relation to Stephens's travelogue, see Jennifer L. Roberts, *Mirror-Travels: Robert Smithson and History* (New Haven: Yale University Press, 2004), 86–113.

4 Smithson described his travels in Mexico as an "anti-expedition" in "Four conversations between Dennis Wheeler and Robert Smithson" (1969–70), ed. Eva Schmidt, in *Robert Smithson: The Collected Writings*, ed. Jack Flam (Berkeley: University of California Press, 1996), 231; Smithson, "Incidents of Mirror-Travel in the Yucatan," 122, 123.

5 While primers to Smithson's interest in sci-fi do appear in a number of texts, they do not delve deeply into the specific cultural, historical, and theoretical issues at stake. See Thomas A. Zaniello, "Our Future Tends to Be Prehistoric: Science Fiction and Robert Smithson," *Arts Magazine*, May 1978, 114–17; Eugenie Tsai, "The Sci-Fi Connection: The IG, J. G. Ballard, and Robert Smithson," in *Modern Dreams: The Rise and Fall of Pop*, ed. Lawrence Alloway (Cambridge, MA.: MIT Press, 1988), 71–74; Robert A. Sobieszek, "Robert Smithson's *Proposal for a Monument at Antarctica*," in *Robert Smithson*, ed. Eugenie Tsai, exh. cat. (Berkeley: University of California Press, 2004), 143–47; and Diana Thater, "A Man Becomes Unstuck in Time in the Film that Became a Classic," in *Robert Smithson Spiral Jetty: True Fictions, False Realities*, ed. Lynne Cooke and Karen Kelly (New York: Dia Art Foundation; Berkeley: University of California Press, 2005), 164–84.

6 While science fiction was not a pervasive interest among Smithson's contemporaries, it did play a key role in the work of certain artists, including various members of the Independent Group (IG), as well as Dan Graham and Peter Hutchinson. Smithson stands as an ideal case study because of the recurrence of sci-fi in his work throughout his career, as well as his pronounced literary sensibility, which allows for close comparisons with science-fiction texts.

7 Joanna Russ, "The Aesthetics of Science Fiction," in *To Write Like a Woman: Essays in Feminism and Science Fiction* (Bloomington: University of Indiana Press, 1995), 10.

8 Clement Greenberg, "Avant-Garde and Kitsch," in *Clement Greenberg: The Collected Essays and Criticism*, vol. 1, ed. John O'Brian (Chicago: University of Chicago Press, 1986), 7.

9 Clement Greenberg, "Aesthetics as Science: Review of *The Structure of Art* by Carl Thurston" (1941), in *Clement Greenberg: The Collected Essays and Criticism*, vol. 1, ed. John O'Brian (Chicago: University of Chicago Press, 1986), 47.

10 Clement Greenberg, "The Present Prospects of American Painting and Sculpture," in *Clement Greenberg: The Collected Essays and Criticism*, vol. 2, ed. John O'Brian (Chicago: University of Chicago Press, 1986), 164.

11 Pete Conrad, quoted in Norman Mailer, *Of a Fire on the Moon* (Boston: Little Brown, 1970), 48.

12 Robert Smithson, "A Museum of Language in the Vicinity of Art" (1968), in *Robert Smithson: The Collected Writings*, ed. Jack Flam (Berkeley: University of California Press, 1996), 91.

13 J. G. Ballard, "Which Way to Inner Space," *New Worlds* 40, no. 118 (May 1962): 118.

14 Robert Smithson, "Quick Millions," in *Robert Smithson: The Collected Writings*, ed. Jack Flam (Berkeley: University of California Press, 1996), 3.

15 "Where that is what I would call the conceptual fallacy, where physical reality isn't like that. . . . It's admitting that most of our abstractions are hypothetical." Smithson, "Four Conversations," 203.

16 Smithson, "Incidents of Mirror-Travel in the Yucatan," 128.

17 Paul Cummings, "Interviews with Robert Smithson for the Archives of American Art" (1972), in *Robert Smithson: The Collected Writings*, ed. Jack Flam (Berkeley: University of California Press, 1996), 295.

18 Jennifer Roberts rightly criticizes Smithson's essentializing of primitivism in the context of his Yucatán essay, whereby he uncritically accepts the exotic otherness of the landscape: "Smithson's Yucatan narrative was fully commensurate with the broader cultural project of dehistoricizing the Maya, for it repressed both the historical experience of the ancient Maya and the political existence of the contemporary Maya." See Roberts, *Mirror-Travels*, 110.

19 Smithson, "Incidents of Mirror-Travel in the Yucatan," 120.

20 Robert Smithson "Fragments of an Interview with P. A. [Patsy] Norvell," in *Robert Smithson: The Collected Writings*, ed. Jack Flam (Berkeley: University of California Press, 1996), 194.

21 Smithson, "Incidents of Mirror-Travel in the Yucatan," 119.

22 Ibid., 122.

23 Smithson, "Fragments of an Interview with P.A. [Patsy] Norvell," 193.

24 J.G. Ballard, *The Drowned World* (1962; repr., New York: Liveright, 2012), 58, 25.

25 Smithson, "Incidents of Mirror-Travel in the Yucatan," 120. As Jennifer Roberts notes, this quote is actually excerpted from Michel Butor's *Degrees* (1961), a novel about a teacher obsessed with transcribing reality in its entirety, and it has no origin in Maya or Aztec culture; see Roberts, *Mirror-Travels*, 155n57. Further, Smithson erroneously describes Tezcatlipoca as a Maya rather than an Aztec god. While Smithson's elision of radically different cultures speaks to a potentially problematic universalizing of the "primitive other," I argue such errors can also be understood as part of Smithson's process of fictional world building via the bricolage of multiple sources as a means to disrupt any singular, true meaning.

26 Ballard, *The Drowned World*, 56.

27 Smithson, "Incidents of Mirror-Travel in the Yucatan," 121.

28 Ballard, *The Drowned World*, 86.

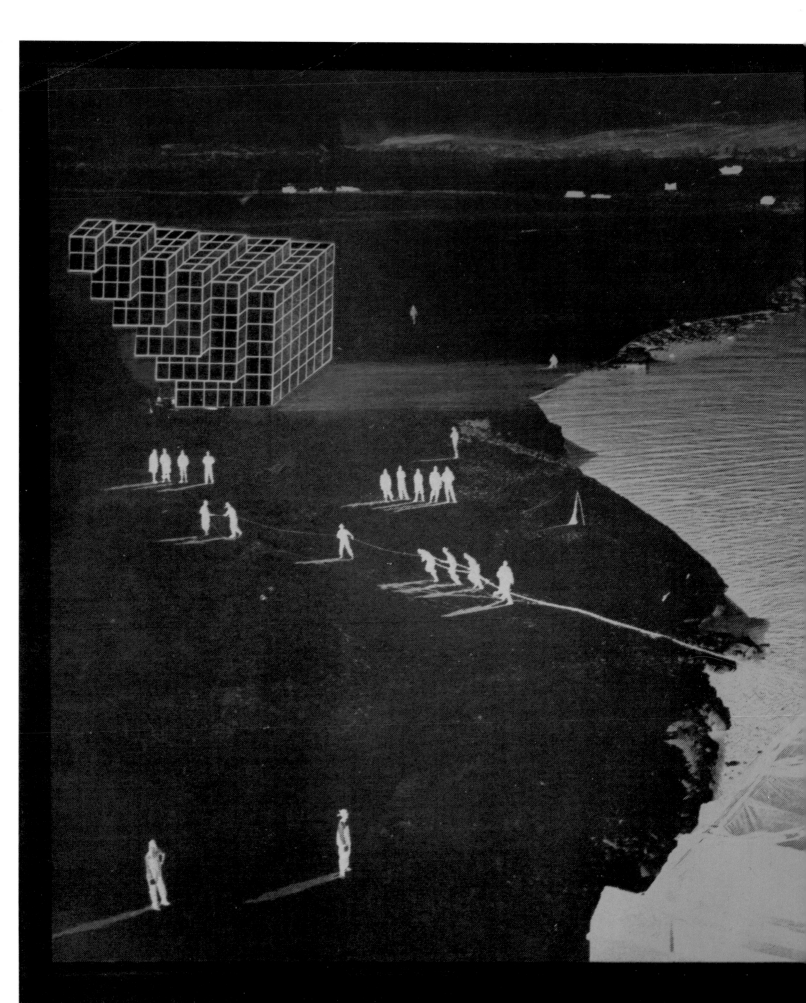

'66

R. Smithson

Plate 42

ROBERT SMITHSON (American, 1938–1973)

Proposal for a Monument at Antarctica, 1966

Negative photostat

7¹¹⁄₁₆ × 11 in. (19.5 × 27.9 cm)

The Metropolitan Museum of Art, New York; Purchase, The Horace W. Goldsmith Foundation Gift, through Joyce and Robert Menschel, 2001 (2001.292)

© Estate of Robert Smithson / Licensed by VAGA, New York, NY

Jan. 12-18, 1970 *Parícutin Volcano Project.*

Displayed at one-man show at John Gibson.
7 photos of 250 yr (in 3 strips) of
mold grown on bread at crater rim. Photos
taken from ground & air. Mr. & Mrs.
Horace Solomon bought 2 photos to
pay for printing cost. — ▓▓ *Time*
payed expenses of trip & gave me a
3 day daily wage.

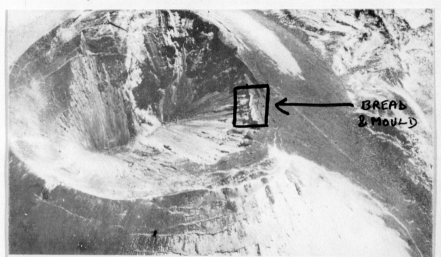

BREAD & MOULD

Peter Hutchinson Paricutin Volcano Feb 14 – Mar 31
John Gibson Commissions, Inc. 27 East 67 New York

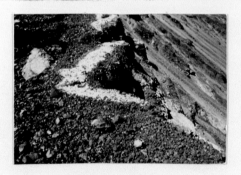
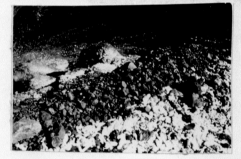

Peter Hutchinson

Plate 44
PETER HUTCHINSON (American, b. in
England, 1930)
Parícutin Volcano Project, 1970
Graphite, ink, photographs, and offset
lithograph
12 × 9 in. (30.5 × 22.9 cm)
Gilbert B. and Lila Silverman
Collection, Detroit

A

B

Plate 45

DAN GRAHAM (American, b. 1942)

2 Correlated Rotations; Two Correlated Spirals, 1972

Black-and-white photographs and graphite on two sheets of graph paper

10 × 8⅛ in. (25.4 × 20.6 cm);
11⅞ × 8⅛ in. (30.2 × 20.6 cm)

Gilbert B. and Lila Silverman Collection, Detroit

Two Correlated
Spirals/
Rotations
(~~~~~~~)
~~~~ Helixes

Two
Correlated
Rotations
Helixes
Energy

I

B

(A)

II

B

B

B

B

(A)

B        B

outside walkers
aim to have
his camera / body /
eye centered
on circle from
which he is
spiraling
as he walks

simultaneously
inside camera / eye /
person is stationary
but camera describes /
his body

B is to think he _is_ A

A is to think he is his camera | That he is
not A looking
at B and the
outside
world

the spiral is _in_ → to A
calculated so in turn so
they are thus mostly filming each
other and so they meet to exchange
exchange cameras at top/ A's eye-level —
then a) The rehearse
(a) rung              or
walk )         b) A takes B's camera to his feet
and begins over     Dan Graham 1973

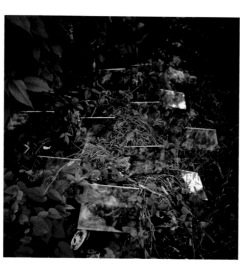
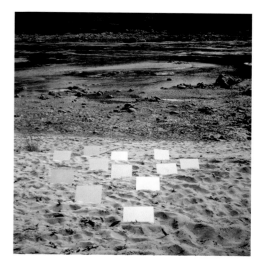
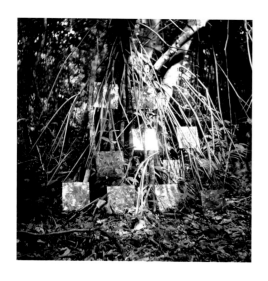

Plate 46

ROBERT SMITHSON (American, 1938–1973)

*Yucatan Mirror Displacements (1–9)*,
1969

Nine chromogenic prints from 35 mm
slides

24 × 24 in. (61 × 61 cm) each

Solomon R. Guggenheim Museum,
New York; Purchased with funds
contributed by the Photography
Committee and with funds contrib-
uted by the International Director's
Council and Executive Committee
Members: Edythe Broad, Henry
Buhl, Elaine Terner Cooper, Linda
Fischbach, Ronnie Heyman, Dakis

Joannou, Cindy Johnson, Barbara Lane,
Linda Macklowe, Brian McIver, Peter
Norton Foundation, Willem Peppler,
Denise Rich, Rachel Rudin, David
Teiger, Ginny Williams, and Elliot K.
Wolk (99.5269)

# SELECTED BIBLIOGRAPHY

Aldiss, Brian W. *Cryptozoic!* Garden City, NY: Doubleday, 1967.

Artundo, Particia. *Xul Solar: Visiones y revelaciones.* Exhibition catalogue. Buenos Aires: Museo de Arte Latinoamericano de Buenos Aires, 2006.

Ballard, J.G. "The Coming of the Unconscious." *New Worlds* 164 (July 1966): 141–45.

———. *The Drowned World.* 1962. Reprint, New York: Liveright Publishing Corporation, 2012.

Bell, Andrea. "'Desde Júpiter': Chile's Earliest Science-Fiction Novel." *Science Fiction Studies* 22, no. 2 (July 1995): 187–97.

Bell, Andrea, and Moisés Hassón. "Prelude to the Golden Age: Chilean Science Fiction, 1900–1959." *Science Fiction Studies* 25, no. 2 (July 1998): 285–99.

Bell, Andrea, and Yolanda Molina-Gavilán, eds. *Cosmos Latinos: An Anthology of Science Fiction from Latin America and Spain.* Middletown, CT: Wesleyan University Press, 2003.

Benedit, Luis, and Jorge Glusberg. *Luis F. Benedit en el Museo Nacional de Bellas Artes: Obras 1960–1996.* Exhibition catalogue. Buenos Aires: Museo Nacional de Bellas Artes, 1996.

Bioy Casares, Adolfo. *The Invention of Morel and Other Stories from "La Trama Celeste."* Austin: University of Texas Press, 1964.

Brown, J. Andrew. *Cyborgs in Latin America.* New York: Palgrave Macmillan, 2010.

Burbano Valdes, Andres Eduardo. "Inventions at the Borders of History: Resignificance of Media Technologies from Latin America." PhD diss., University of California, Santa Barbara, 2013.

Burnham, Jack. *Beyond Modern Sculpture: The Effects of Science and Technology on the Sculpture of This Century.* New York: G. Braziller, 1968.

Busa, Christopher, ed. *Dissolving Clouds: Writings of Peter Hutchinson.* Provincetown, MA: Provincetown Arts Press, 1994.

Castañeda, Luis M. "Doubling Time." *Grey Room* 51 (Spring 2013): 12–39.

Cheng, John. *Astounding Wonder: Imagining Science and Science Fiction in Interwar America.* Philadelphia: University of Pennsylvania Press, 2012.

Corn, Joseph J, and Brian Horrigan. *Yesterday's Tomorrows: Past Visions of the American Future.* Edited by Katherine Chambers. Baltimore: Johns Hopkins University Press, 1996.

Dallal, Alberto, ed. *El Futuro: XXXI Coloquio Internacional de Historia del Arte.* Mexico City: Universidad Nacional Autónoma de México, 2010.

de Lauretis, Teresa, Andreas Huyssen, and Kathleen Woodward, eds. *The Technological Imagination: Theories and Fictions.* Madison, WI: Coda Press, 1980.

Dziubinskyj, Aaron. "The Birth of Science Fiction in Spanish America." *Science Fiction Studies* 30, no. 1 (March 2003): 21–32.

Fernández Delgado, Miguel Ángel. *Visiones periféricas: Antología de la ciencia ficción mexicana.* Mexico City: Grupo Editorial Lumen, 2001.

Filippone, Christine. "Cosmology and Transformation in the Work of Michelle Stuart." *Women's Art Journal* 32, no. 1 (Spring/Summer 2011): 3–12.

Flam, Jack, ed. *Robert Smithson: The Collected Writings.* Berkeley: University of California Press, 1996.

Fox, Claire F. *Making Art Panamerican: Cultural Policy and the Cold War.* Minneapolis: University of Minnesota Press, 2013.

Ginway, M. Elizabeth. *Brazilian Science Fiction: Cultural Myths and Nationhood in the Land of the Future.* Lewisburg, PA: Bucknell University Press, 2004.

Ginway, M. Elizabeth, and J. Andrew Brown. *Latin American Science Fiction: Theory and Practice.* New York: Palgrave Macmillan, 2012.

Gioni, Massimiliano, and Gary Carrion-Murayari. *Ghosts in the Machine.* Exhibition catalogue. New York: The New Museum of Contemporary Art, 2012.

Giunta, Andrea. *Avant-Garde, Internationalism, and Politics: Argentine Art in the Sixties.* Durham, NC: Duke University Press, 2007.

Goizueta, Elizabeth T., ed. *Matta: Making the Invisible Visible.* Exhibition catalogue. Chestnut Hill, MA: McMullen Museum of Art, Boston College, 2004.

Gómez-Sicre, José. *Rudy Ayoroa of Bolivia.* Exhibition catalogue. Washington, DC: Pan-American Union, 1968.

González, Julieta. *Juan Downey: Una utopía de la comunicación.* Exhibition catalogue. Mexico City: Museo Rufino Tamayo, 2013.

———. *El mañana ya estuvo aquí.* Exhibition catalogue. Mexico City: Museo Rufino Tamayo, 2013.

Goodwin, Matthew David. "The Fusion of Migration and Science Fiction in Mexico, Puerto Rico, and the United States." PhD diss., University of Massachusetts, Amherst, 2013.

Goodyear, Anne Collins. "The Relationship of Art to Science and Technology in the United States, 1957–1971: Five Case Studies." PhD diss., University of Texas, 2002.

Hamner, Everett. "Remembering the Disappeared: Science Fiction Film in Post-Dictatorship Argentina." *Science Fiction Studies* 39, no. 1 (March 2012): 60–80.

Haywood Ferreira, Rachel. *The Emergence of Latin American Science Fiction.* Middletown, CT: Wesleyan University Press, 2011.

———. "'Más Allá,' 'El Eternauta,' and the Dawn of the Golden Age of Latin American Science Fiction (1953–59)." *Extrapolation* 51, no. 2 (Summer 2010): 281–303.

Henderson, Linda Dalrymple. *Reimagining Space: The Park Place Gallery Group in 1960s New York.* Exhibition catalogue. Austin, TX: Blanton Museum of Art, The University of Texas at Austin, 2008.

Hunter, Christina. "Mapping Space and Time." In *Nancy Graves Project and Special Guests*, edited by Brigitte Franzen and Annette Lagler, 112–25. Ostfildern: Hatje Cantz; Aachen: Ludwig Forum Aachen, 2013.

Hutchinson, Peter. "Science-Fiction: An Aesthetic for Science." *Art International* 7, no. 8 (October 20, 1968): 32–34, 41.

Hutchinson, Peter, and Oliver Kornhoff. *Peter Hutchinson: Erträumte Paradiese.* Exhibition catalogue. Remagen, Germany: Arp Museum, 2009.

Jameson, Fredric. *Archaeologies of the Future: The Desire Called Utopia and Other Science Fictions.* New York: Verso, 2005.

Keith, Naima J., and Zoé Whitley, eds. *The Shadows Took Shape.* Exhibition catalogue. New York: Studio Museum in Harlem, 2013.

Kerslake, Patricia. *Science Fiction and Empire.* Liverpool: Liverpool University Press, 2007.

Lee, Pamela M. *Chronophobia: On Time in the Art of the 1960s.* Cambridge, MA: MIT Press, 2004.

Lem, Stanislaw. *Solaris.* Translated by Joanna Kilmartin and Steve Cox. New York: Berkley Books, 1971.

Lippard, Lucy R. *Overlay: Contemporary Art and the Art of Prehistory.* New York: Pantheon Books, 1983.

López Anaya, Jorge. "Emilio Renart: La búsqueda de una creatividad integral." In *Ruth Benzacar*, edited by D.E. Larriqueta and Victoria Verlichak, 175–76. Buenos Aires: Fundación Espigas, 2005.

Lovatt, Anna, et al. *Michelle Stuart: Drawn from Nature.* Ostfildern: Hatje Cantz, 2013.

McCray, Patrick. *The Visioneers: How a Group of Elite Scientists Pursued Space Colonies, Nanotechnologies, and a Limitless Future.* Princeton: Princeton University Press, 2012.

Molina-Gavilán, Yolanda, et al. "Chronology of Latin American Science Fiction, 1775–2005." *Science Fiction Studies* 34, no. 3 (November 2007): 369–431.

Morineau, Camille, ed. *Gyula Kosice.* Exhibition catalogue. Paris: Centre Pompidou, 2013.

O'Dea, Rory. "Science Fiction and Mystic Fact: Robert Smithson's Ways of World-Making." PhD diss., Institute of Fine Arts, New York University, 2013.

Paz, Mariano. "South of the Future: An Overview of Latin American Science Fiction Cinema." *Science Fiction Film and Television* 1, no. 1 (2008): 81–103.

Pérez-Barreiro, Gabriel, ed. *Blanton Museum of Art: Latin American Collection.* Austin: Blanton Museum of Art, The University of Texas at Austin, 2006.

Pérez-Barreiro, Gabriel, and Gyula Kosice. *Gyula Kosice: In Conversation with Gabriel Pérez-Barreiro.* New York: Fundación Cisneros/Colección Patricia Phelps de Cisneros, 2012.

Petersen, Stephen. *Space-Age Aesthetics: Lucio Fontana, Yves Klein, and the Postwar European Avant-Garde.* University Park, PA: Pennsylvania State University Press, 2009.

Puig, Ivan, and Andrés Padilla Domene. *SEFT-1: Sonda de exploración ferroviaria tripulada.* Mexico City: Dirección General de Publicaciones del Consejo Nacional para la Cultura y las Artes, 2011.

Ramírez, Mari Carmen, and Héctor Olea, eds. *Inverted Utopias: Avant-Garde Art in Latin America.* Houston: Museum of Fine Arts; New Haven: Yale University Press, 2004.

*Raquel Forner: Space Mythology = Mythologie Spatiale.* Washington, DC: Corcoran Gallery of Art, 1974.

Rebetez, René. *Contemporáneos del porvenir: Primera antología colombiana de ciencia ficción.* Santa Fe, Bogotá: Planeta Colombiana Editorial, 2000.

Rieder, John. *Colonialism and the Emergence of Science Fiction.* Middletown, CT: Wesleyan University Press, 2008.

Rivera, Lysa. "Future Histories and Cyborg Labor: Reading Borderlands Science Fiction after NAFTA." *Science Fiction Studies* 39, no. 3 (November 2012): 415–36.

Roberts, Jennifer L. *Mirror-Travels: Robert Smithson and History.* New Haven: Yale University Press, 2004.

Sawin, Martica. *Surrealism in Exile and the Beginning of the New York School.* Cambridge, MA: MIT Press, 1995.

Schmelz, Itala, ed. *El futuro más acá: Cine mexicano de ciencia ficción.* Mexico City: Difusión Cultural UNAM, Filmoteca UNAM, Landucci, 2006.

Smith, Valerie, ed. *Juan Downey: The Invisible Architect.* Exhibition catalogue. Cambridge, MA: MIT List Visual Arts Center; Bronx, NY: Bronx Museum of the Arts, 2011.

Smithson, Robert, and Nancy Holt. *The Writings of Robert Smithson: Essays with Illustrations.* New York: New York University Press, 1979.

Suvin, Darko. *Metamorphoses of Science Fiction: On the Poetics and History of a Literary Genre.* New Haven: Yale University Press, 1979.

Tattersfield, Regina. "René Rebetez y La Magia." *Revista Visaje*, November 8, 2012. http://revistavisaje.com/?p=651.

Tsai, Eugenie. "The Sci-Fi Connection: The IG, J.G. Ballard, and Robert Smithson." In *Modern Dreams: The Rise and Fall and Rise of Pop*, edited by Lawrence Alloway, 71–76. Cambridge, MA: MIT Press, 1988.

Turner, Fred. *From Counterculture to Cyberculture: Stewart Brand, the Whole Earth Network, and the Rise of Digital Utopianism.* Chicago: University of Chicago Press, 2006.

von Däniken, Erich. *Chariots of the Gods?: Unsolved Mysteries of the Past.* New York: Putnam, 1970.

von Schlegell, Mark. "Dan Graham Science Fiction." In *Dan Graham: Beyond*, edited by Bennett Simpson and Chrissie Iles, 209–18. Cambridge, MA: MIT Press, 2009.

**Sarah J. Montross** is the Andrew W. Mellon Post-doctoral Curatorial Fellow at the Bowdoin College Museum of Art in Brunswick, Maine, where she has cocurated several exhibitions, including *Breakthrough: Work by Contemporary Chinese Women Artists* (2013). She earned her PhD at the Institute of Fine Arts, New York University, with a dissertation on the pioneering Latin American video artists Juan Downey and Jaime Davidovich. A specialist in modern and contemporary art of the Americas, Montross recently contributed an essay, "Nostalgia for the Future: Time, Technology, and Origins in Juan Downey's Art," to the Museo Rufino Tamayo catalogue *Juan Downey: A Communications Utopia* (2013).

Based in Argentina, **Rodrigo Alonso** is a curator and theoretician of contemporary art and new media. He has published widely on the subject of technology-based arts, particularly of Latin America. He has organized numerous exhibitions, including Fundación Proa's *Art of Contradictions: Pop, Realisms, and Politics; Brazil/Argentina, 1960s* (2012), *Situating No-Land: Videoart from Latin America* (2011), Frankfurter Kunstverein's *Tales of Resistance and Change* (2010), and Cultural Center España Córdoba's *Out! Art in Public Spaces* (2010, cocurated with Gerardo Mosquera). In 2011, he was the curator of the Argentine Pavilion at the 54th Venice Biennale. He has taught graduate and postgraduate courses at Latin American and European universities and serves as an advisor for international art foundations.

**Miguel Ángel Fernández Delgado**, who lives and works in Mexico City, is a writer and historian. He is coeditor of *Alambique: Revista académica de ciencia ficción y fantasía/Jornal académico de ficção científica e fantasía* (Academic journal of science fiction and fantasy) at the University of South Florida, where he is associate researcher and curator of the Spanish-language science-fiction special collections. He is the author of *Visiones Periféricas: Antología de la ciencia ficción mexicana* (2001; Peripheral visions: Anthology of Mexican science fiction), among many other books and articles. He has been involved in the research and planning of numerous exhibitions, including the forthcoming University of California, Riverside, ARTSblock's *Critical Utopias: The Art of Futurismo Latino*.

**Rory O'Dea** is an art historian who has written widely on Robert Smithson. He is currently working on a study of Smithson's work in relation to science-fiction literature and a narrative chronology of the artist Louise Bourgeois, which will be included in Robert Storr's forthcoming monograph, *Intimate Geometries: The Life and Work of Louise Bourgeois*. He has taught in the MFA program at the Yale University School of Art and currently teaches at Parsons The New School for Design. He earned his PhD in art history from the Institute of Fine Arts, New York University, and lives in Brooklyn.

# ILLUSTRATION CREDITS

Unless otherwise noted, photographs were provided by the owners of the works of art and are published with their permission; their generosity is gratefully acknowledged. In some instances, we were unable to trace copyright holders. The publishers would appreciate notification of additional credits for acknowledgment in future editions.

Published on the occasion of the exhibition *Past Futures: Science Fiction, Space Travel, and Postwar Art of the Americas*, on view at the Bowdoin College Museum of Art, Brunswick, Maine, March 5–June 7, 2015, organized by Sarah J. Montross.

Major support provided by the Andrew W. Mellon Foundation.

Library of Congress Cataloging-in-Publication Data
Past futures (2015)
    Past futures: science fiction, space travel, and postwar art of the Americas / Sarah J. Montross ; with contributions by Rodrigo Alonso, Miguel Ángel Fernández Delgado, Rory O'Dea.
        pages cm
    "Published on the occasion of the exhibition Past Futures: Science Fiction, Space Travel, and Postwar Art of the Americas, on view at the Bowdoin College Museum of Art, Brunswick, Maine, March 5–June 7, 2015, organized by Sarah J. Montross."
    Includes bibliographical references.
    ISBN 978-0-262-02902-5 (alk. paper)
    1. Science fiction in art—Exhibitions. 2. Space flight in art—Exhibitions. 3. Art, American—20th century—Exhibitions. 4. Art, Latin American—20th century—Exhibitions. I. Montross, Sarah J. II. Alonso, Rodrigo. III. Fernández Delgado, Miguel Ángel, 1967– IV. O'Dea, Rory. V. Bowdoin College. Museum of Art. VI. Title.
    N8239.S66P37 2015
    709.7'09045—dc23
                                                        2014041951

Bowdoin College Museum of Art
9400 College Station
Brunswick, ME 04011
www.bowdoin.edu/art-museum

MIT Press
One Rogers Street
Cambridge, MA 02142
www.mitpress.mit.edu

MIT Press books may be purchased at special quantity discounts for business or sales promotional use. For information, please email special_sales@mitpress.mit.edu.

The essays by Rodrigo Alonso and Miguel Ángel Fernández Delgado were translated by Janice Jaffee.

Produced by Marquand Books, Inc., Seattle
www.marquand.com

Edited by Nola Butler
Designed by Zach Hooker
Typeset in Electra and Metro Nova by Maggie Lee
Proofread by Ted Gilley
Color management by iocolor, Seattle
Printed and bound in China by Artron Color Printing Co., Ltd.

Front cover: Ivan Puig and Andrés Padilla Domene, *SEFT-1 over Metlac Bridge* (detail of fig. 29, p. 29), 2011
Back cover: Michelle Stuart, *Moon* (detail of pl. 17), 1969
Page 2: Rufino Tamayo, *Hombre escudriñando el firmamento* (detail of pl. 3), 1949. © Tamayo Heirs / Mexico / Licensed by VAGA, New York, NY
Page 3: Marilyn Bridges, *Overview, Pathway to Infinity, Nazca, Peru* (detail of pl. 26), 1988
Page 4: Nancy Graves, *Part of Sabine D. Region, Southwest Mare Tranquilitatis* (detail of pl. 22), 1972. © Nancy Graves Foundation, Inc. / Licensed by VAGA, New York, NY
Page 5: Robert Smithson, *Proposal for a Monument at Antarctica* (detail of pl. 42), 1966. © Estate of Robert Smithson / Licensed by VAGA, New York, NY
Page 6: Vija Celmins, *Comet* (detail of pl. 20), 1992
Page 7: Henrique Alvim Corrêa, illustration for H.G. Wells, *La guerre des mondes* (detail of fig. 6, p. 55), 1906
Page 8: Rufino Tamayo, *Lunatic* (detail of pl. 8), 1958. © Tamayo Heirs / Mexico / Licensed by VAGA, New York, NY
Pages 14–15: Matta, *La vie est touchée* (detail of pl. 7), 1957
Pages 48–49: Marcelo Bonevardi, *The Supreme Astrolabe* (detail of pl. 23), 1973
Pages 76–77: Emilio Renart, *Drawing No. 13* (detail of pl. 27), 1965
Pages 106–7: Robert Smithson, *Yucatan Mirror Displacements 4, 1* (detail of pl. 46), 1969. © Estate of Robert Smithson / Licensed by VAGA, New York, NY